SCREAMING SKY IS WEIRD.

weird sports

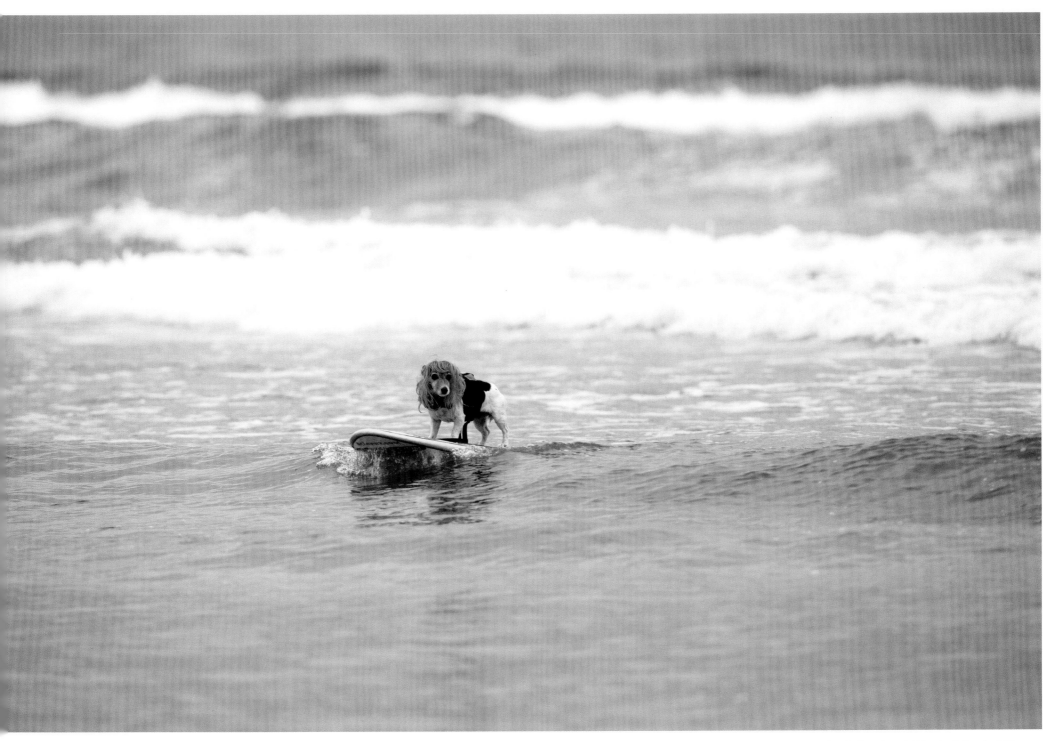

Dog Surfing, Imperial Beach, California, USA

KEHRER

weird sports

Sol Neelman

Foreword

I have never tossed around the old pigskin, swung a tennis racket, or pumped a pom-pom. But in my late twenties everything changed when a friend asked me to do something crazy with her. She asked me to play roller derby.

My love affair with weird sports began in the early eighties when I was a little girl—a socially awkward, terribly uncoordinated, asthmatic little girl. On any given Saturday morning, I could be found planted in front of my family's hardwood and veneer-encased dinosaur of a TV set cheering for the heels of the WWF. That's right, professional wrestling. I would giggle and wheeze with delight during the pre-match interviews as the wrestlers shouted insults, shoving poor Mean Gene, the legendary wrestling announcer, to the side to get at one another. Once the match was under way, you can be sure I was immediately mimicking every bad-guy move in a torturous tirade of body slams, camel clutches, and plain old-fashioned Indian burns, all at the expense of my helpless younger brother.

My little brother quickly grew much bigger and stronger than me, effectively ending my living room professional wrestling career. My athletic skills were stunted, and I spent high school thinking up creative ways to avoid running the mile in gym and sucking on my asthma inhaler.

When I was invited to play roller derby in 2004, the sport's resurgence was in its infancy. There were barely four fully formed leagues around the country. Playing this obscure sport gave me the opportunity to be athletic in a safe environment—one in which no one judged anyone because no one knew what the hell they were doing. And everyone, I mean everyone, fell down. A lot. Beyond that, the sport of roller derby brought with it the badass, do-it-yourself spirit of the women who played it. Lacking the restrictions of the more traditional sports, we were afforded the freedom to express ourselves in any way we chose. Many chose to be their own hero. Harkening back to those Saturday mornings cheering for wrestling's bad boys, I decided to be my own villain: Rettig to Rumble.

I'm not one to do anything half-assed, and I took the villain role seriously. Painting a half skull on the side of my face before taking to the track made me look like and feel the role of the relentless aggressor. It was in stark contrast to my day job as a shy, by-the-book road engineer. It perfectly represented the dual personality within me and the other women who play the sport. When clad in full derby regalia, this vicious roller ghoul was out for blood. And many times, blood is just what I got as our unbridled aggression more often than not led to split lips, broken noses, and the occasional fistfight.

Word of what this tough group of girls was doing spread through the community like wildfire. One day, I got a phone call from some guy claiming to work for a newspaper in Oregon. He said he was interested in taking a few photographs to document what we were up to. Was this guy for real, or was he a crazed lunatic with a penchant for watching women in fishnets compete in brutal hip-to-hip combat? Either way, I didn't care. I immediately invited him to a game.

The first time I was in close proximity to Sol, I didn't see him. I literally did not know he was beside me, nor did I realize he was photographing me. This is remarkable considering Sol is six foot, three inches tall and is usually schlepping around multiple cameras with lenses roughly the size of Philly cheesesteaks. But Sol fit right in. He made himself a natural part of the unpredictable action without ever directly affecting it. In fact, it was only later after seeing the photos he took of me and my team that day that I realized he had been so close to us. But not creepy close. It turns out Sol really was a bona fide photographer. I dodged a bullet on that one.

The weird sports that have been created around the world allow those of us who live ordinary lives, who lug around asthma inhalers and harbor secret desires of being rock stars and pro wrestlers, to momentarily be extraordinary. And I have never seen a photographer more able to pinpoint and capture those extraordinary moments than Sol Neelman. I know of no one else who has the sense of humor necessary to shoot prom dress rugby, the cojones to cover drag queen softball and the fearlessness to allow himself to be used as the buttery topping for a Kaiju wrestling character called French Toast.

Mark Twain said, "Let us live so that when we come to die even the undertaker will be sorry." Sol Neelman's weird sports photography documents that we are.

Brandy Rettig
AKA
Rettig to Rumble

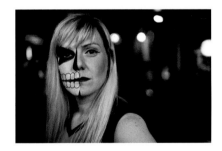

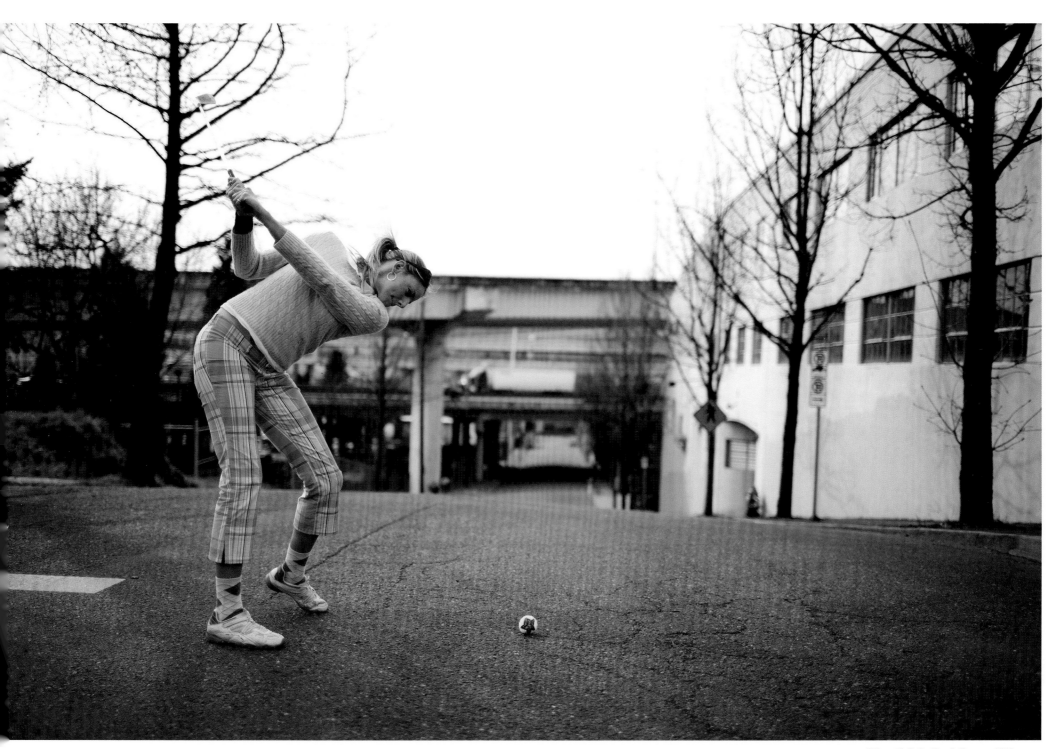

Urban Golf, Portland, Oregon, USA

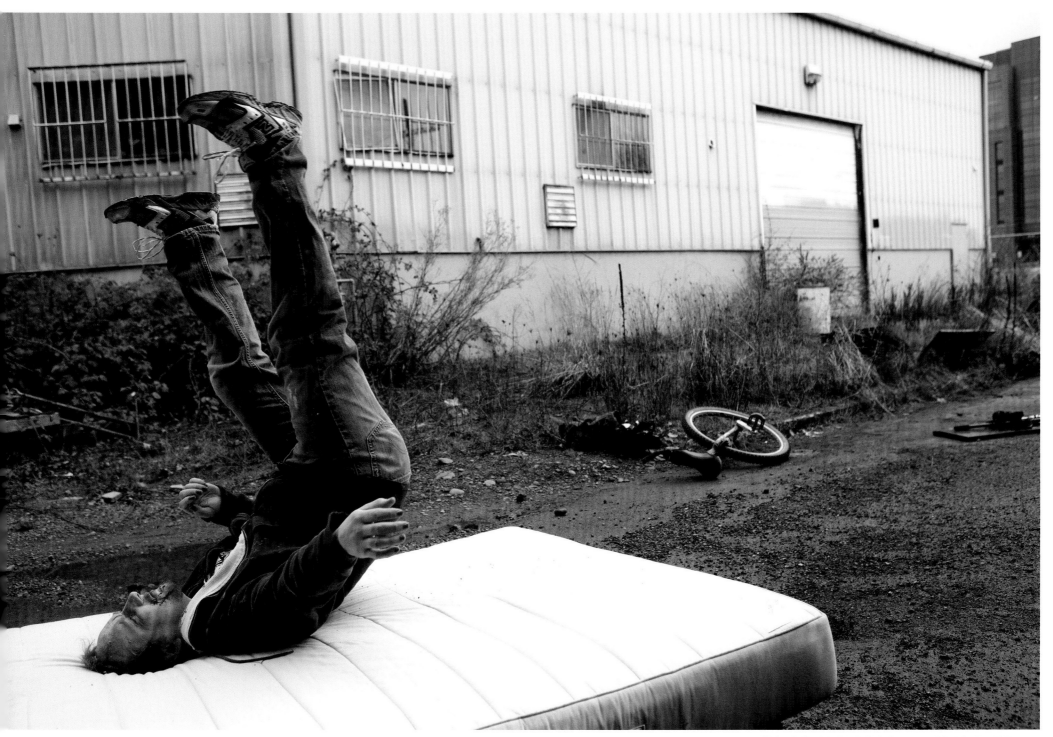

Unicycle Zombie Movie Set, Vancouver, Washington, USA

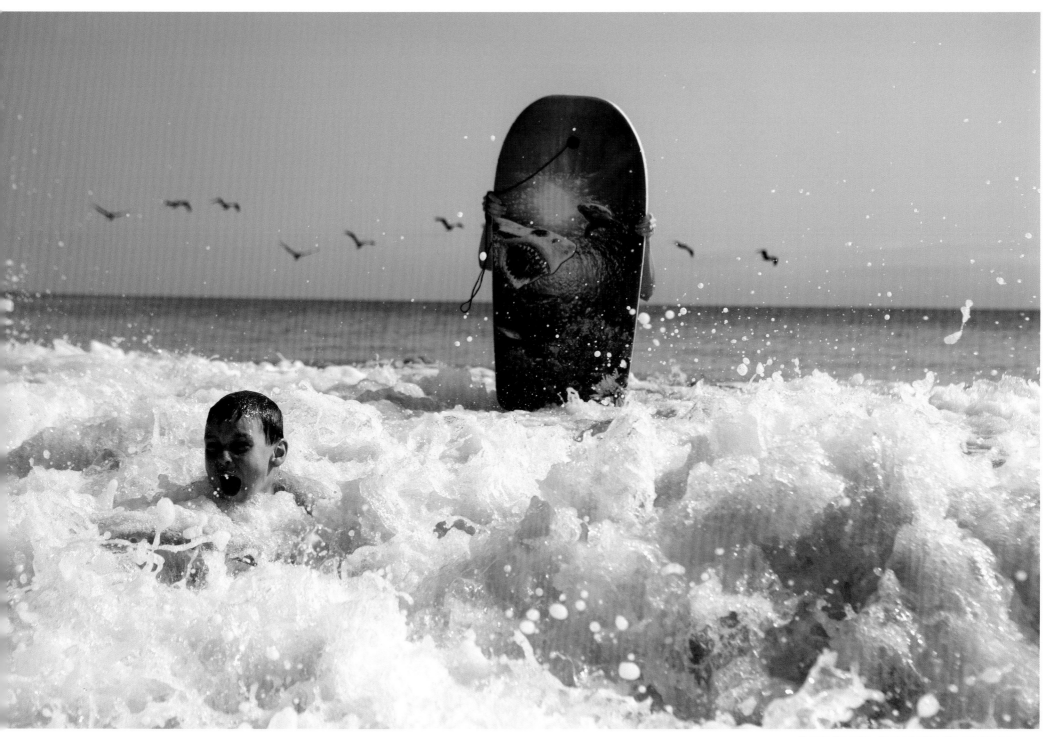

Boogie Boarding, Punta de Mita, Nayarit, Mexico

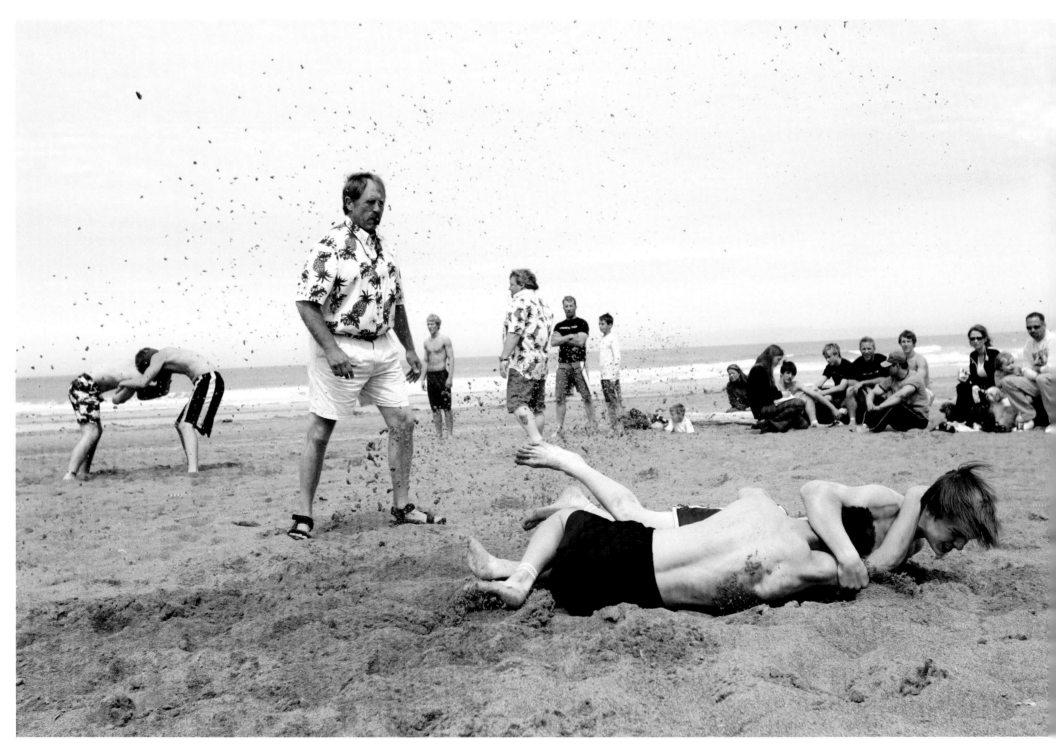

Beach Wrestling, Bandon, Oregon, USA

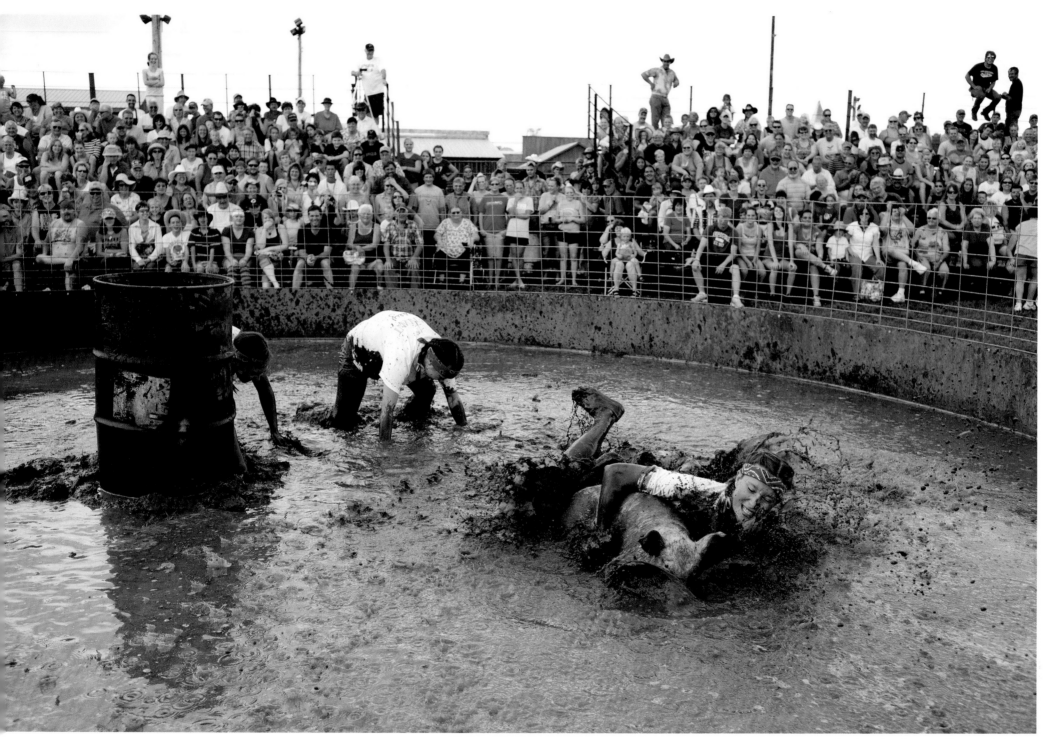

Hog Wrassling, Viroqua, Wisconsin, USA

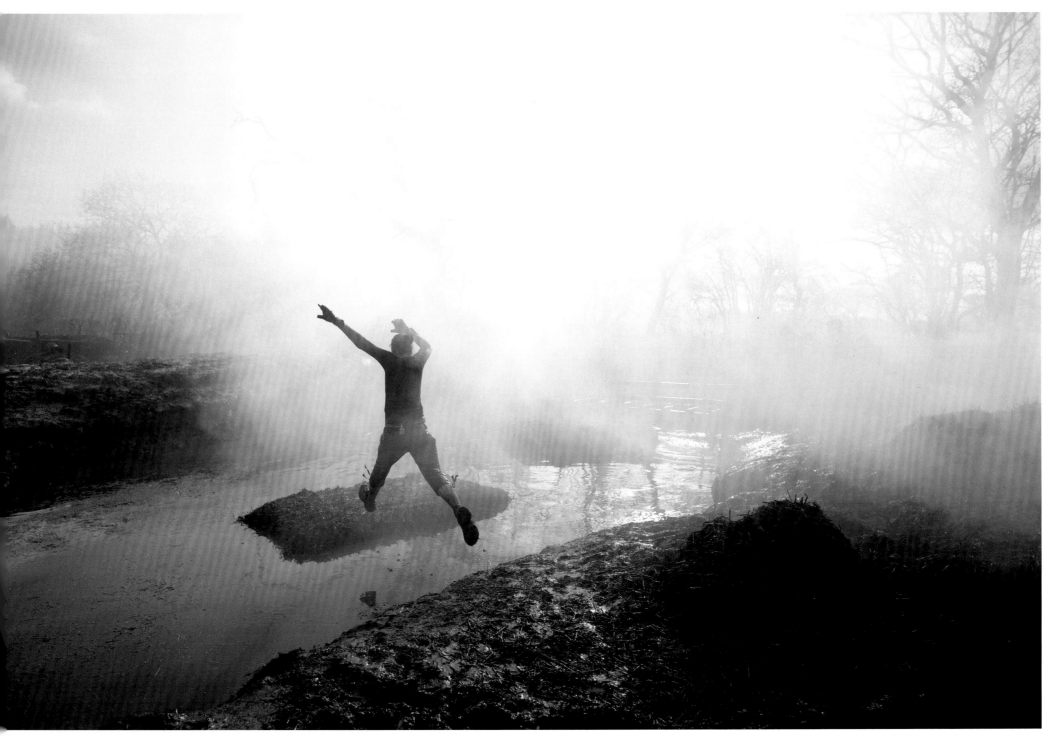

Fiery Holes at Tough Guy ™, Wolverhampton, England

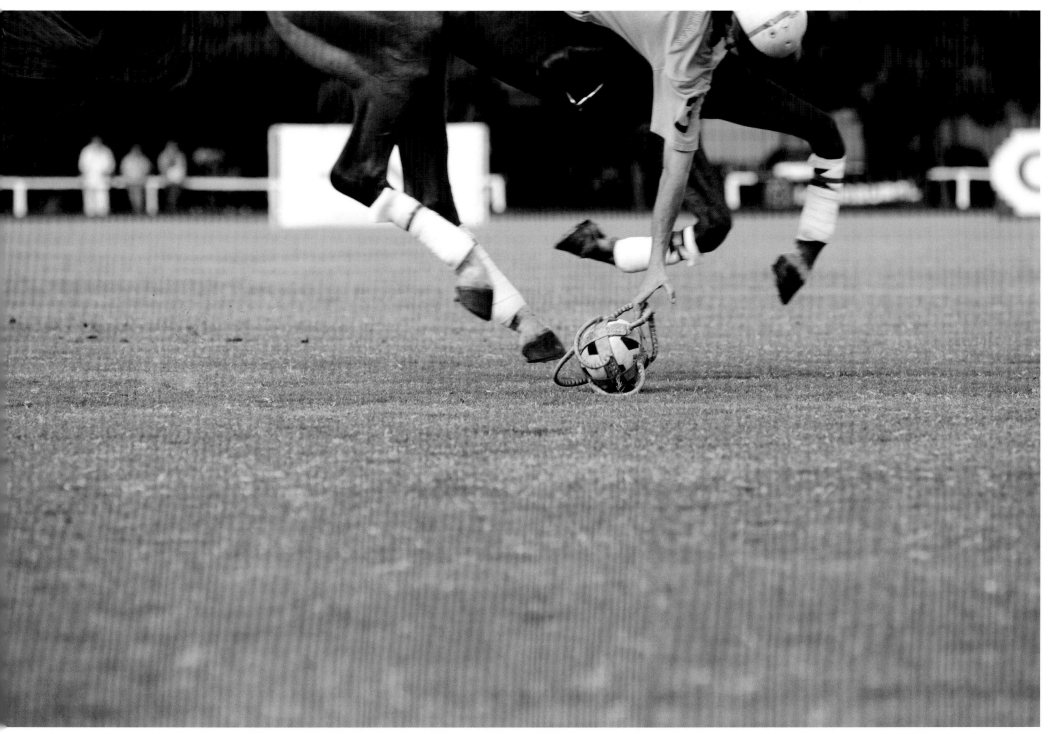

Pato, Buenos Aires, Argentina

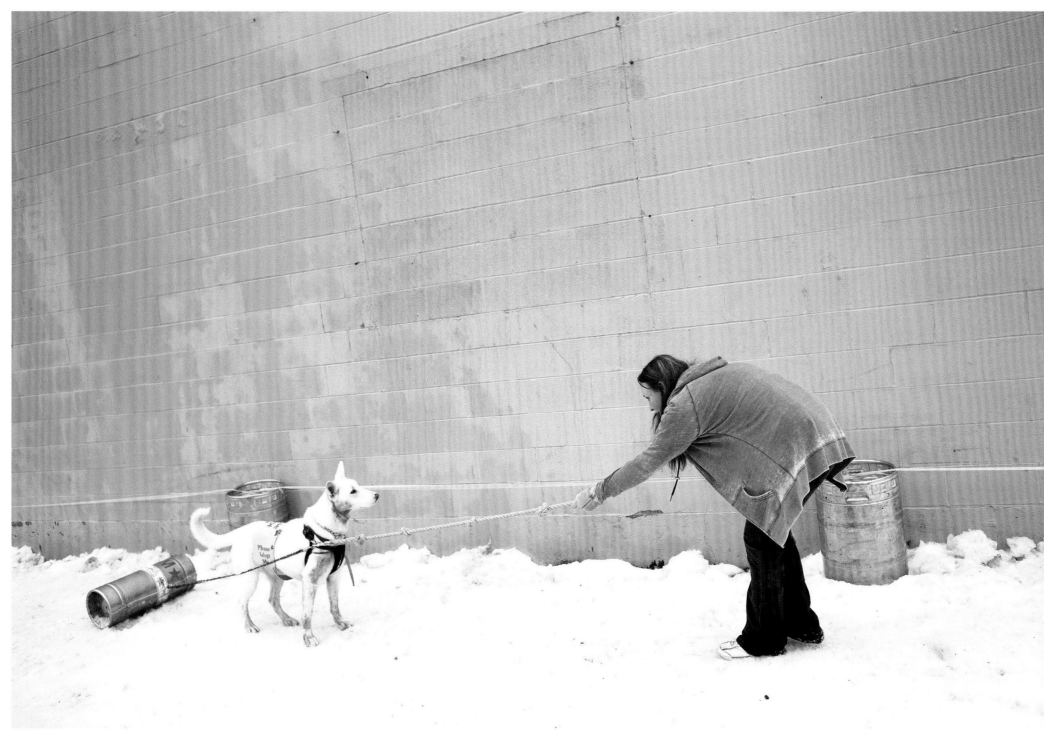

K-9 Keg Pull, Sandpoint, Idaho, USA

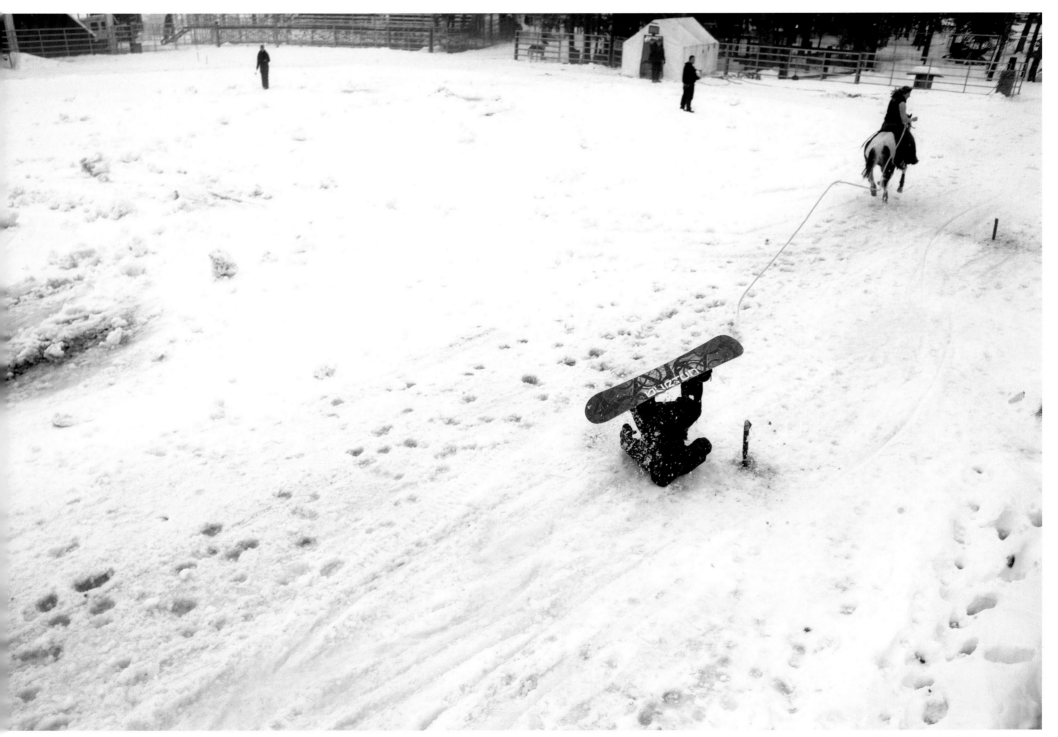

Skijoring, Sandpoint, Idaho, USA

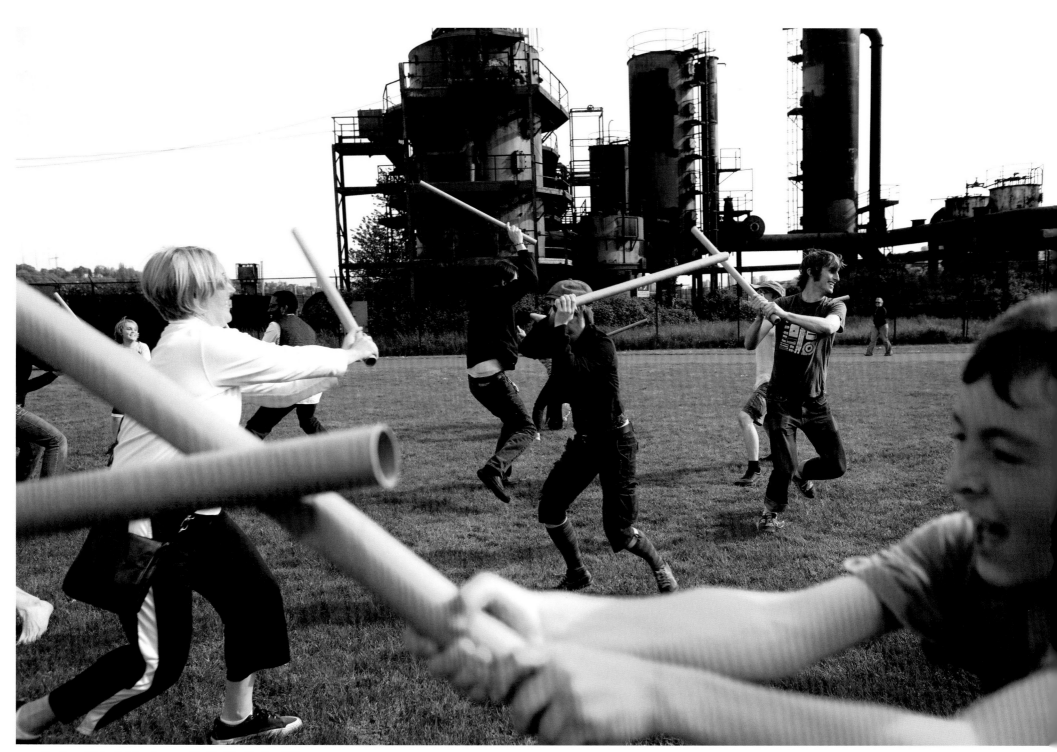

Cardboard Tube Fighting League, Seattle, Washington, USA

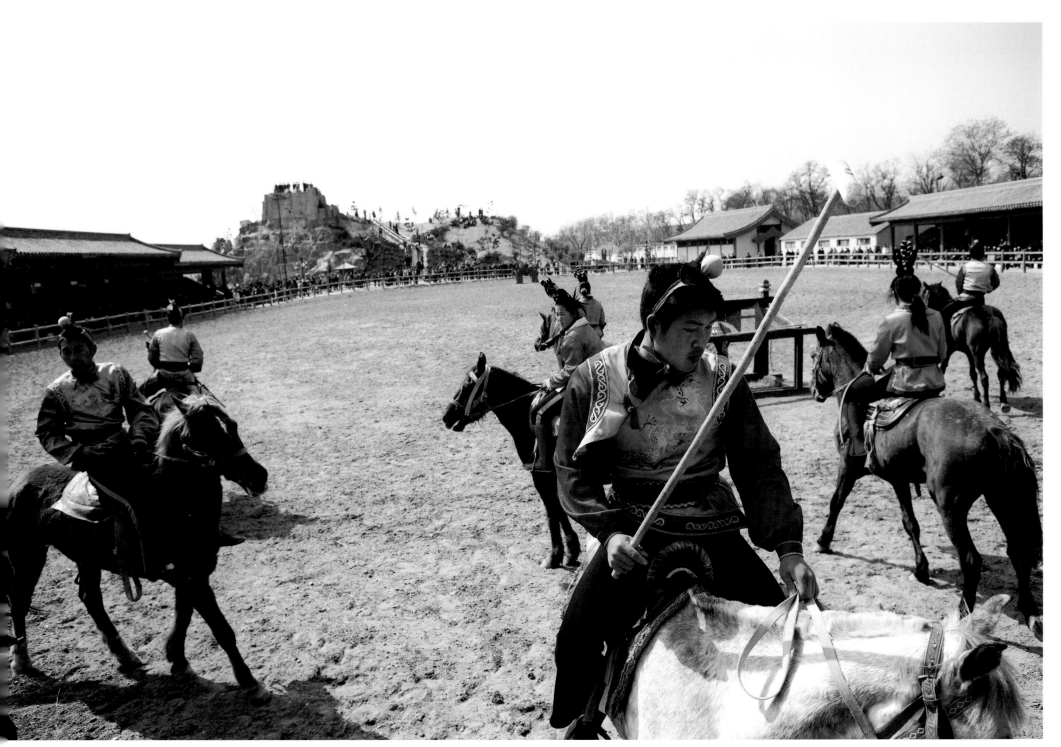

Ancient Polo, Kaifeng, Henan Province, China

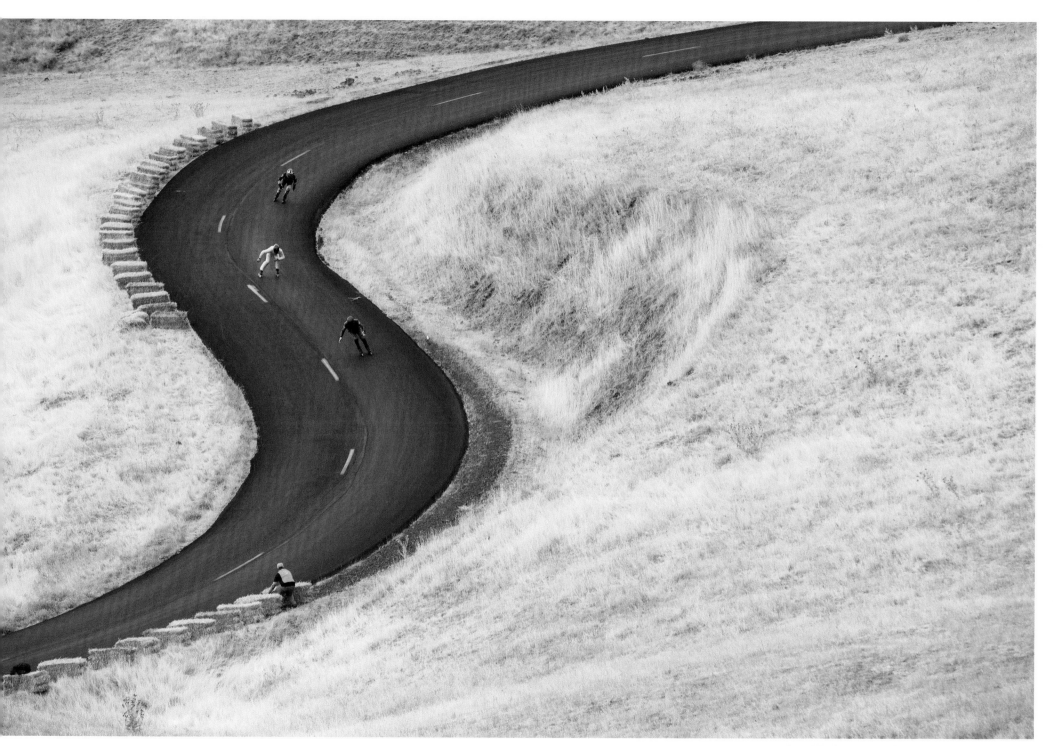

Downhill Inline Skating, Maryhill, Washington, USA

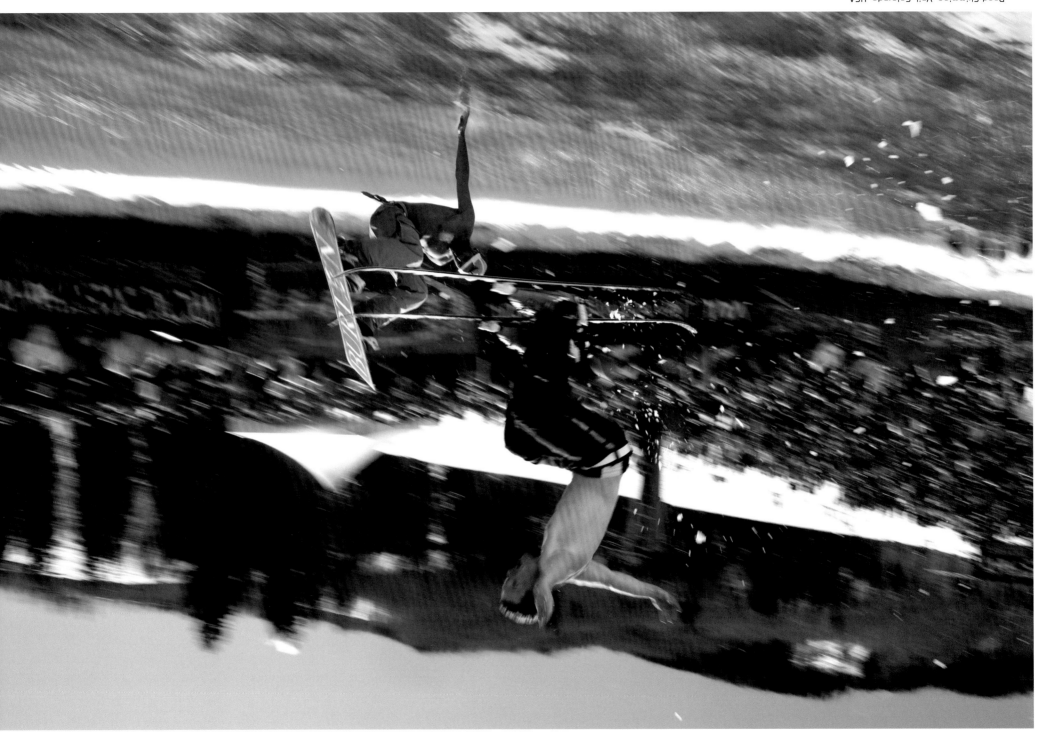

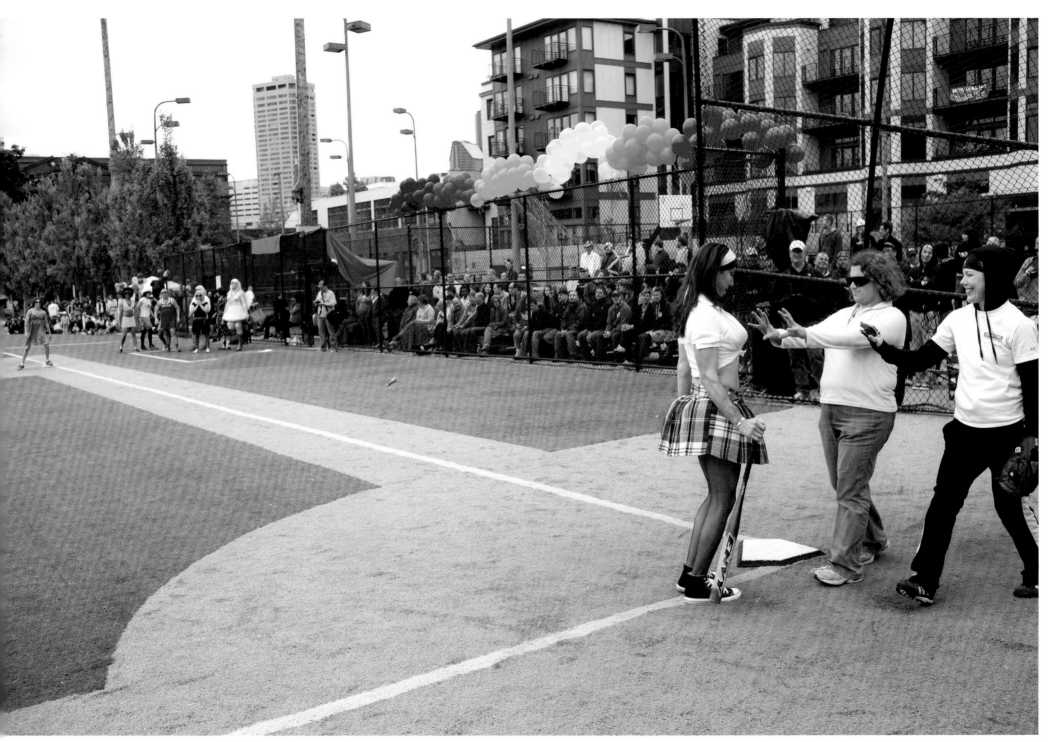

Dykes vs. Drag Queens Softball, Seattle, Washington, USA

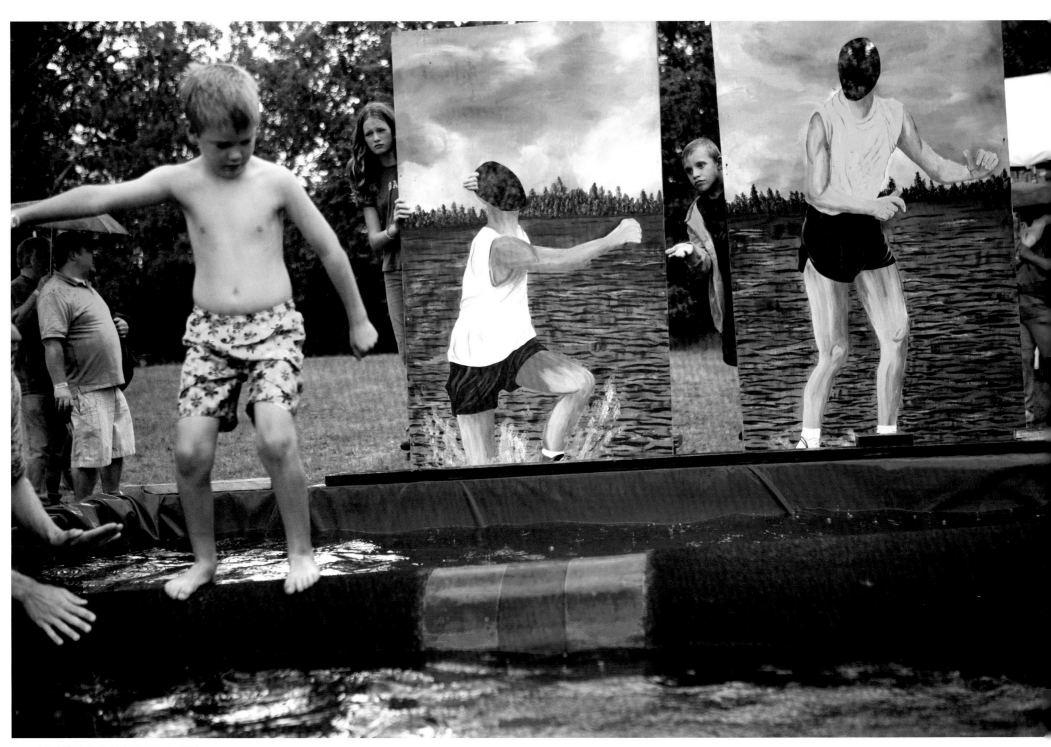

Logrolling, Hayward, Wisconsin, USA

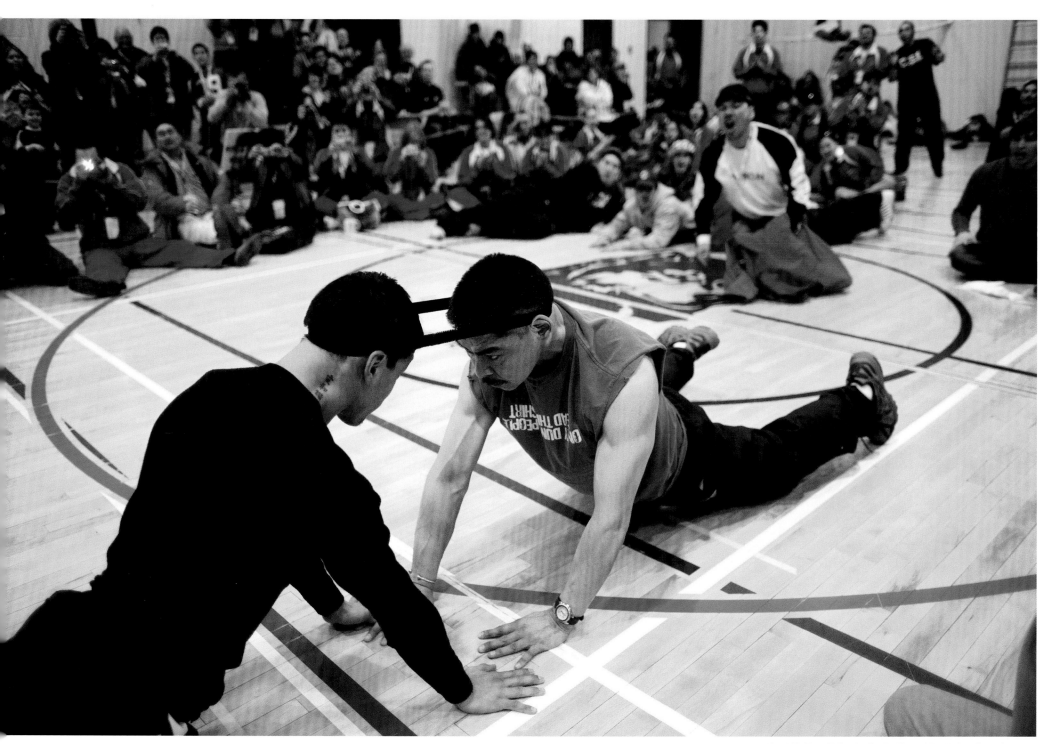

Head Pulling, Yellowknife, Northwest Territories, Canada

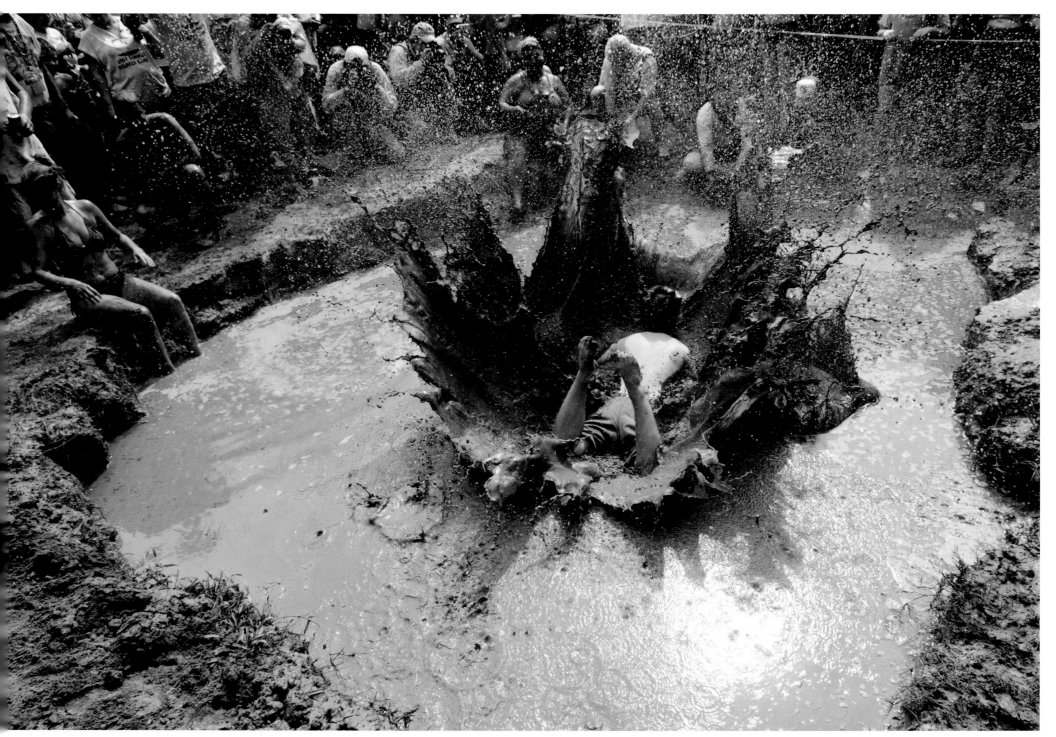

Mud Pit Belly Flop, East Dublin, Georgia, USA

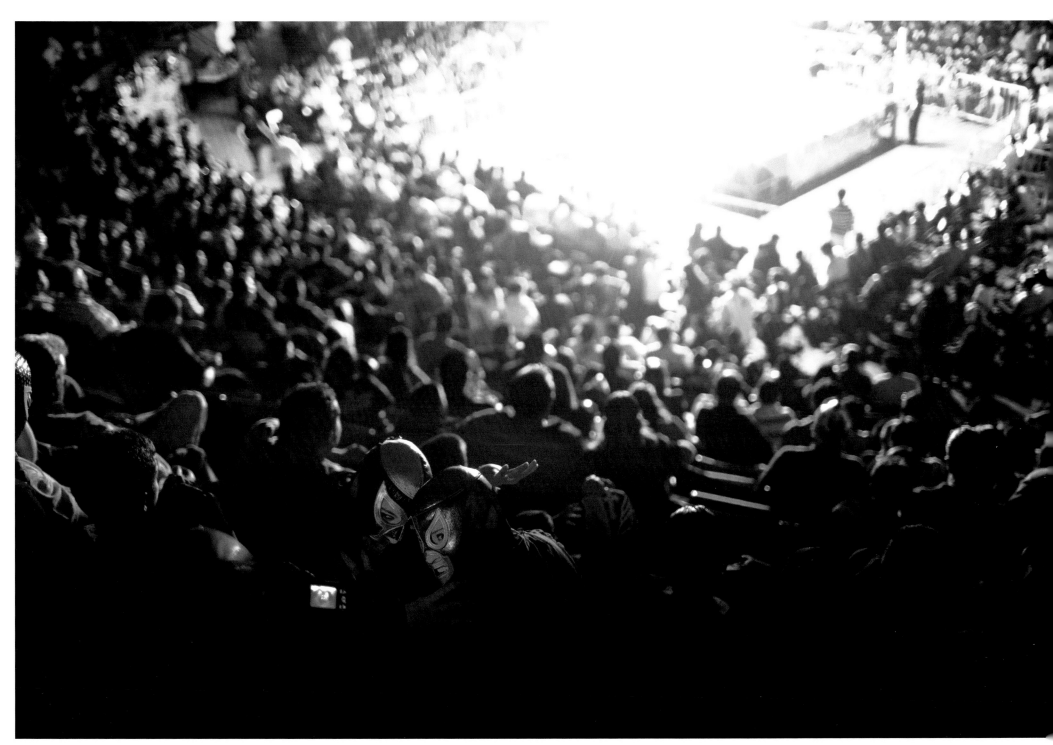

Lucha Libre, Tijuana, Baja California, Mexico

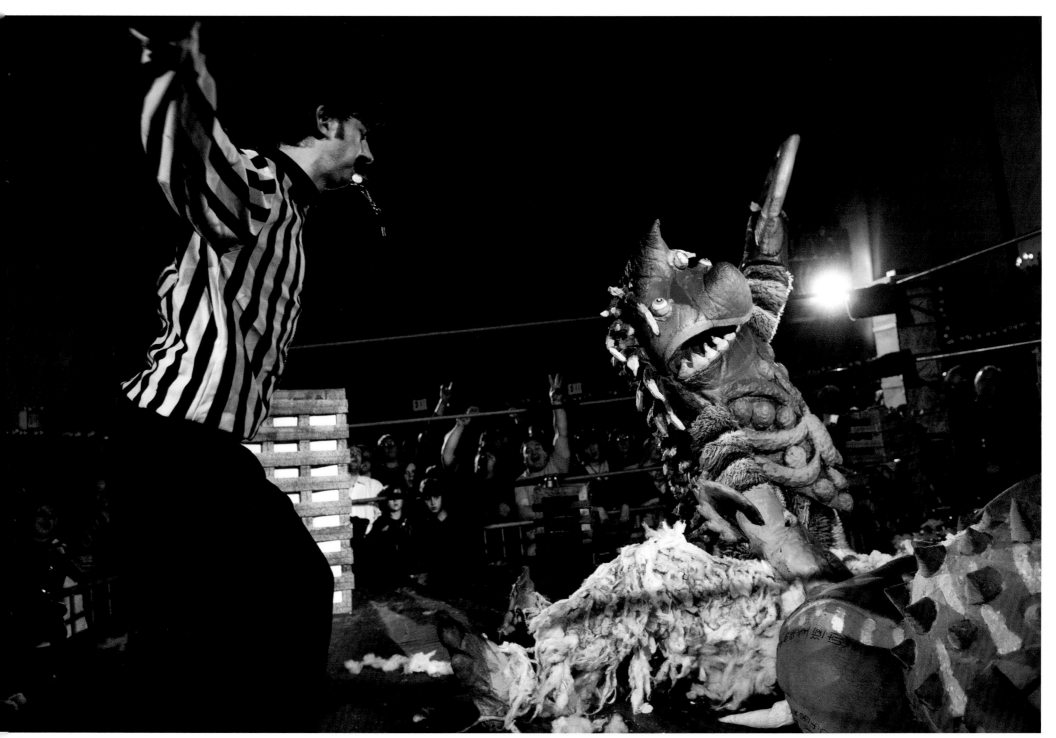

Live Monster Wrestling, Brooklyn, New York, USA

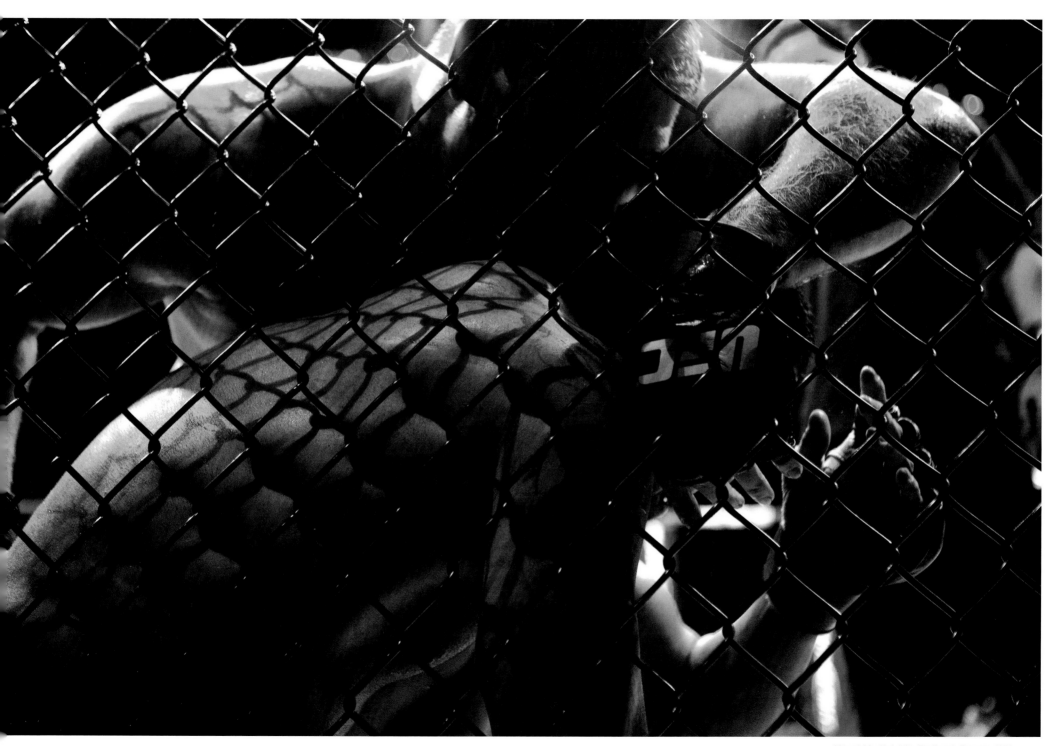

Mixed Martial Arts, Portland, Oregon, USA

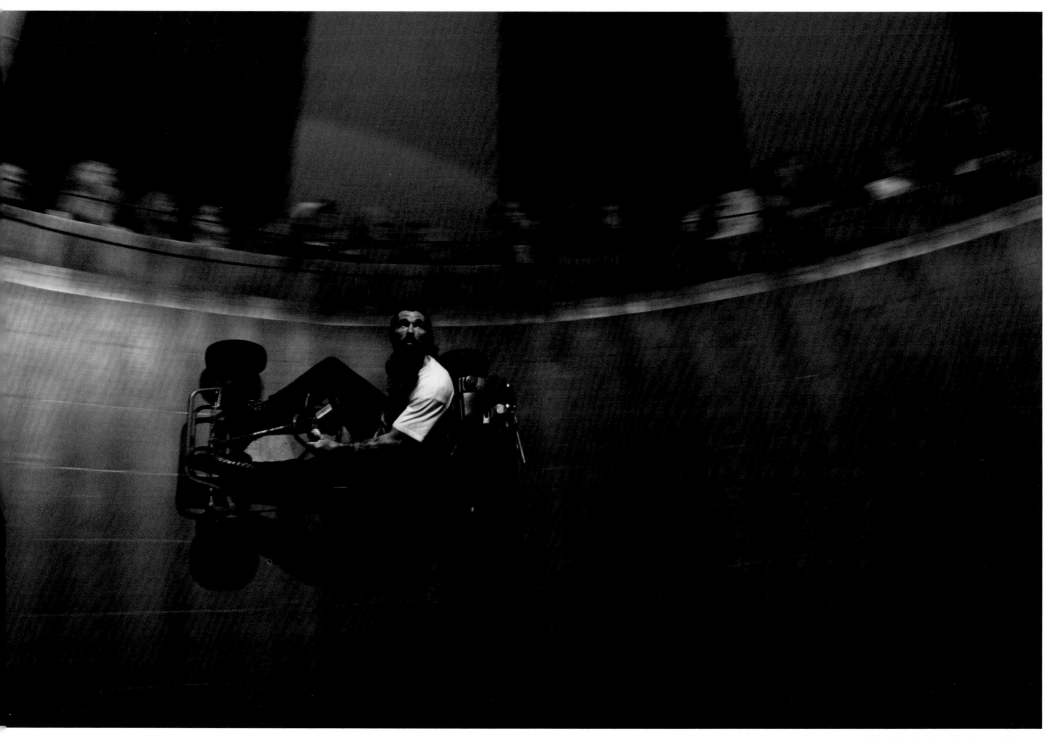

Wall of Death, Butte, Montana, USA

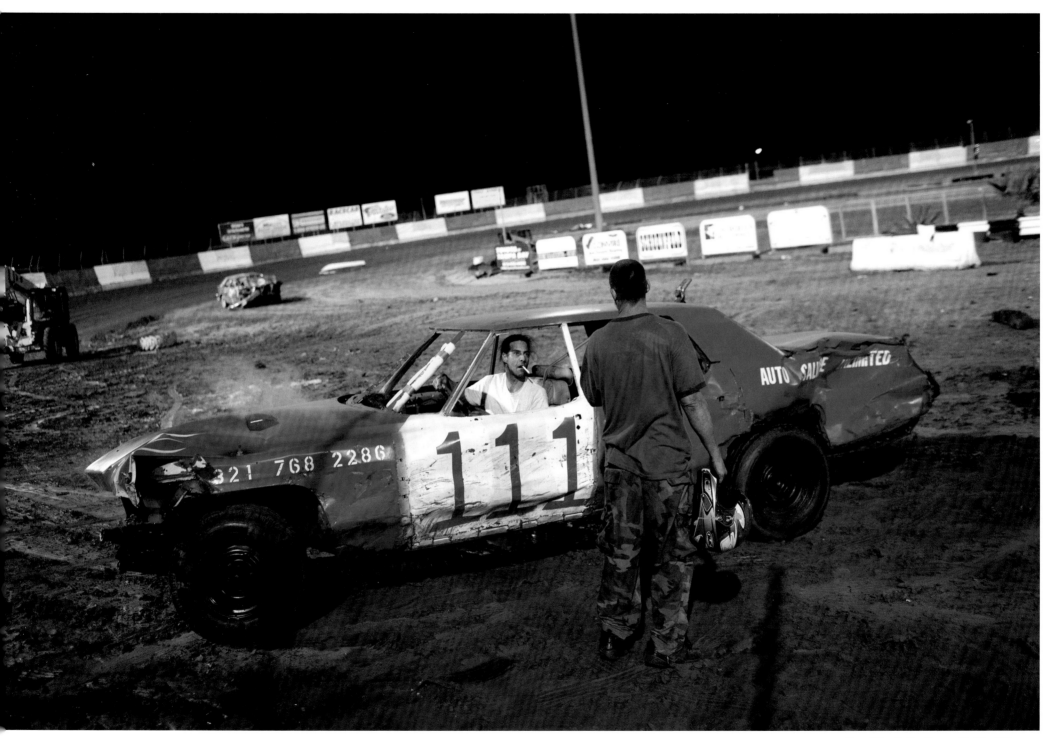

Demolition Derby, Tampa, Florida, USA

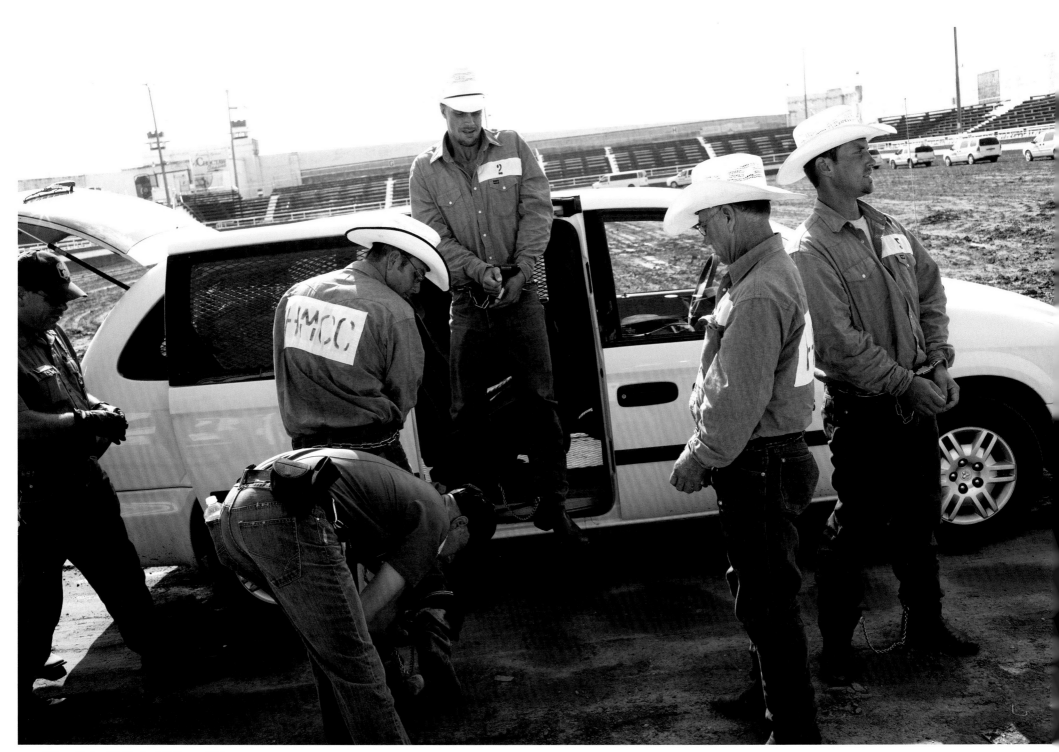

Prison Rodeo, McAlester, Oklahoma, USA

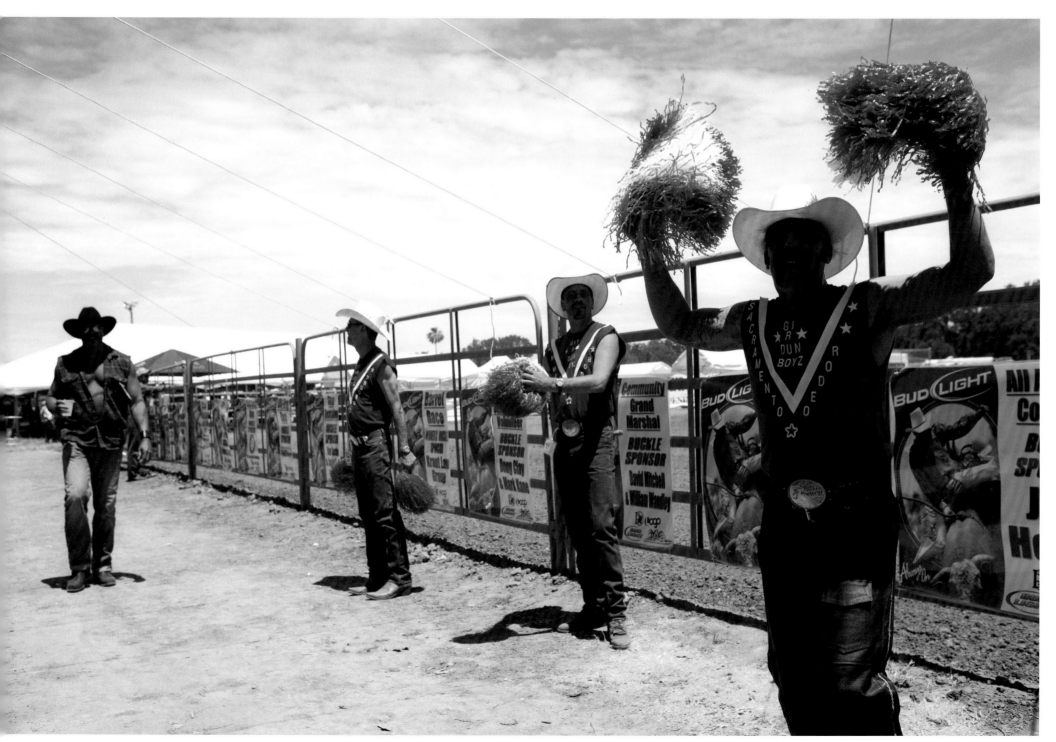

Gay Rodeo, Rio Linda, California, USA

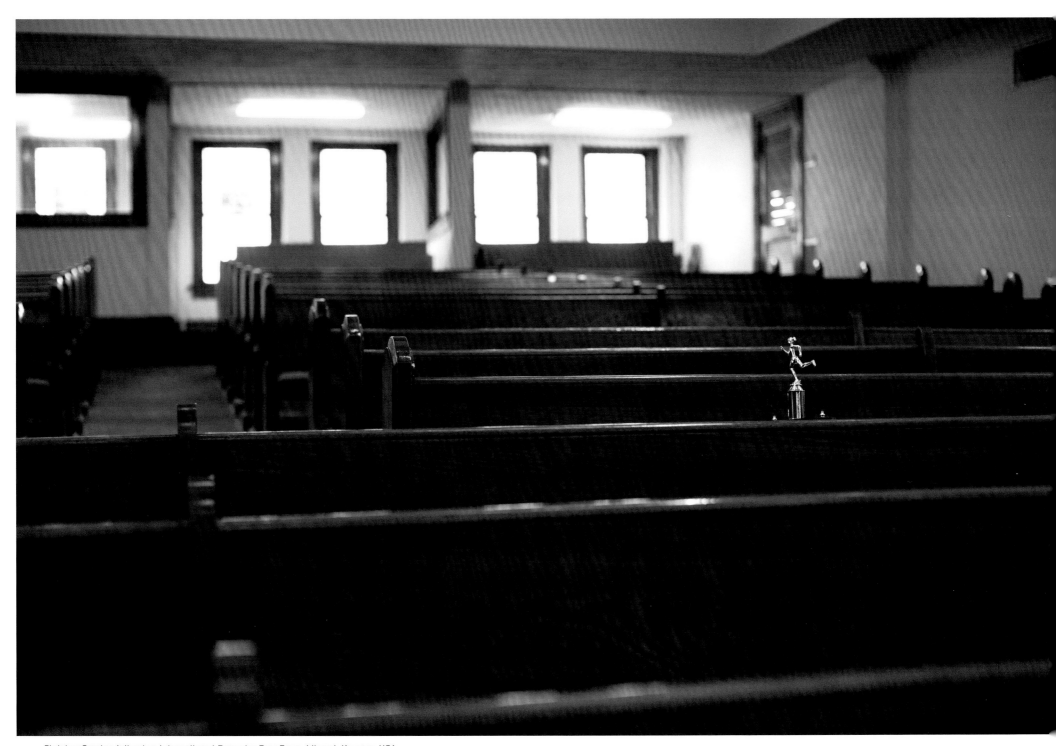

Shriving Service following International Pancake Day Race, Liberal, Kansas, USA

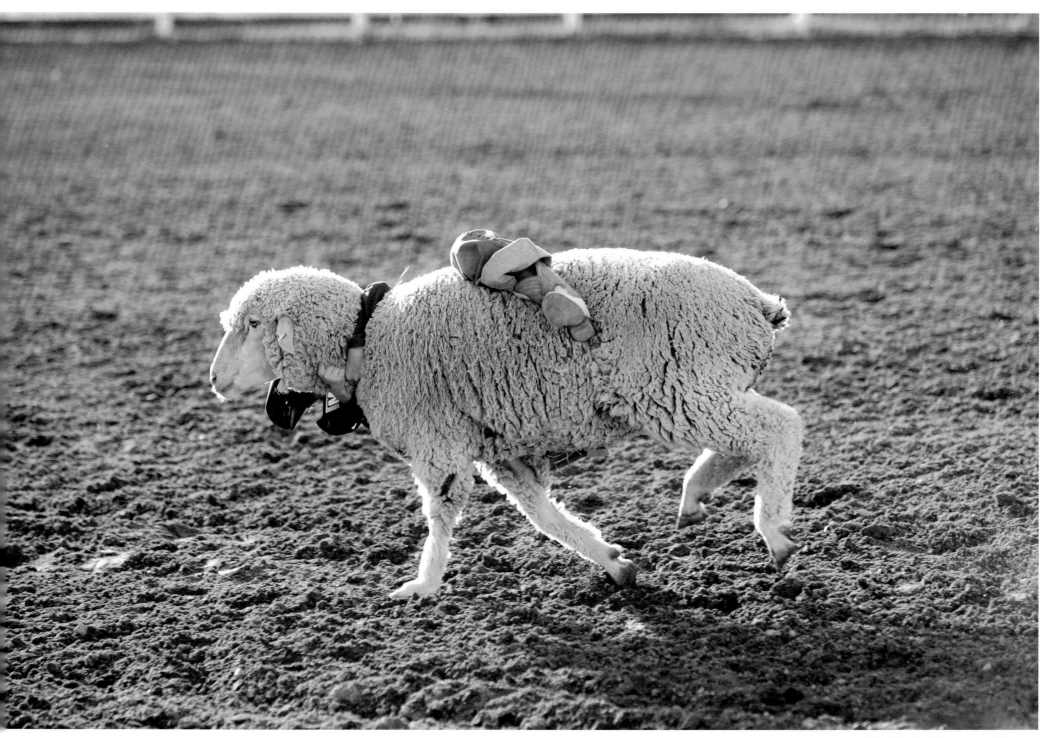

Mutton Busting, Vale, Oregon, USA

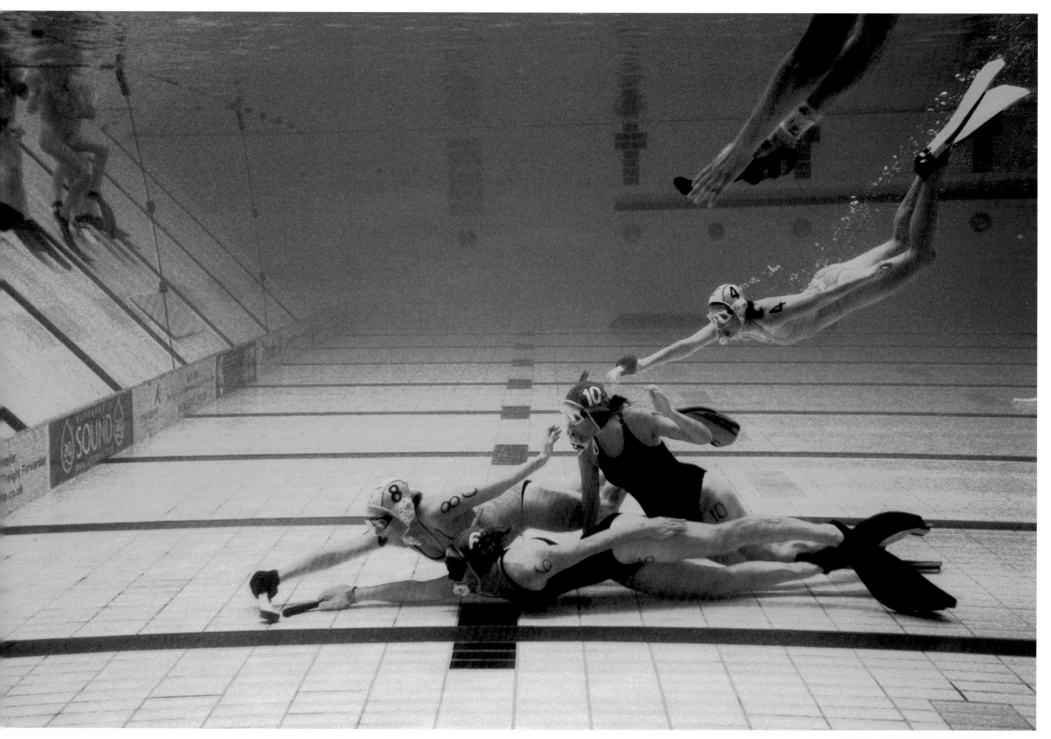

Underwater Hockey, Sheffield, England

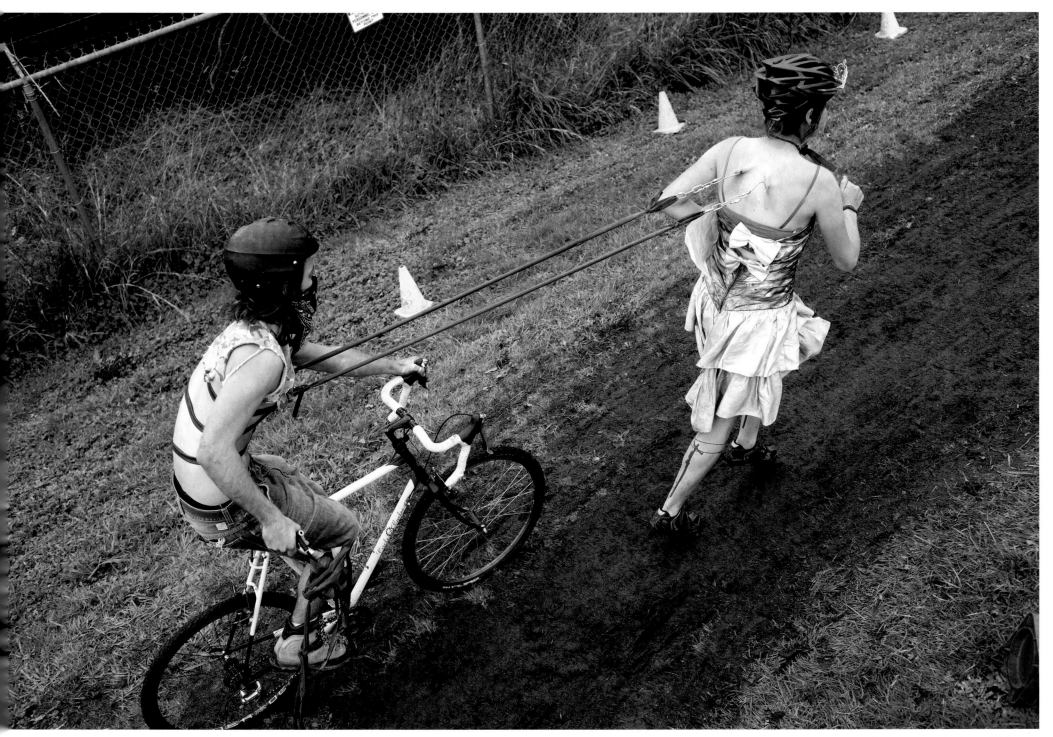

Cyclocross, Astoria, Oregon, USA

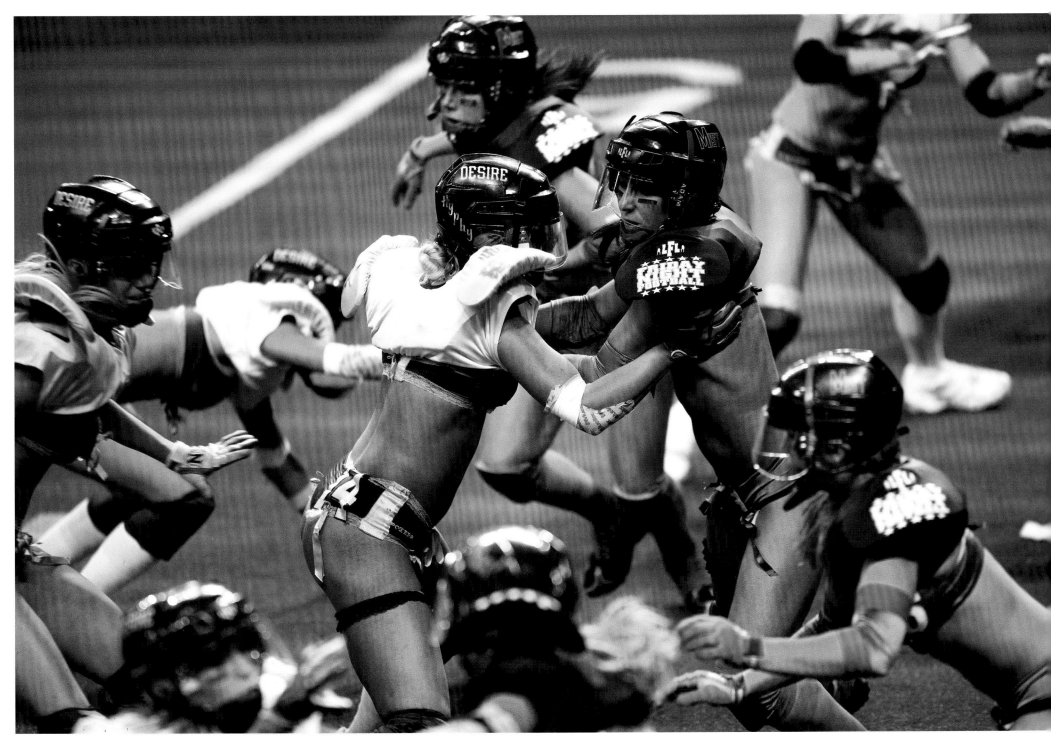

Lingerie Football, Kent, Washington, USA

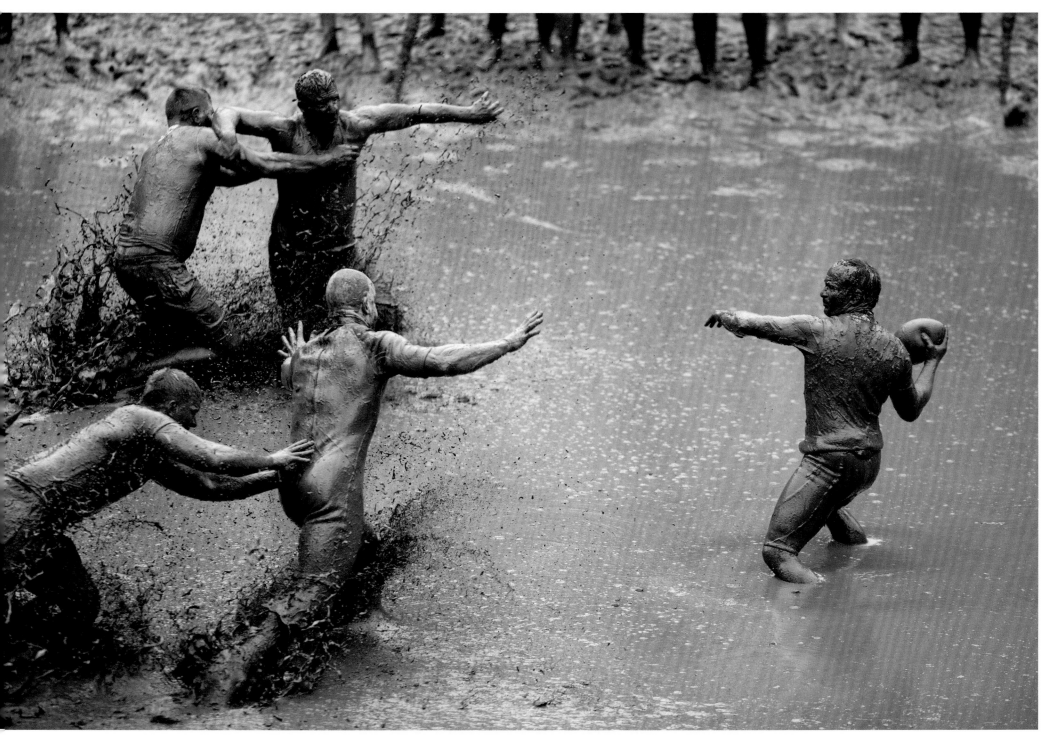

Mud Football, North Conway, New Hampshire, USA

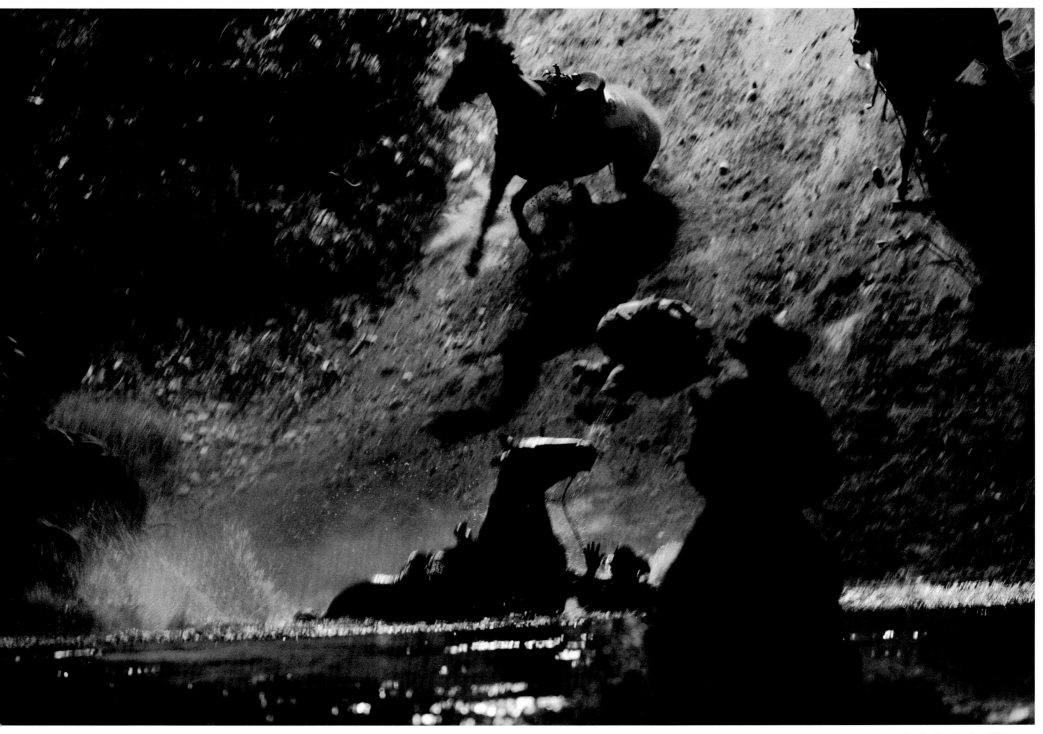

Suicide Race, Omak, Washington, USA

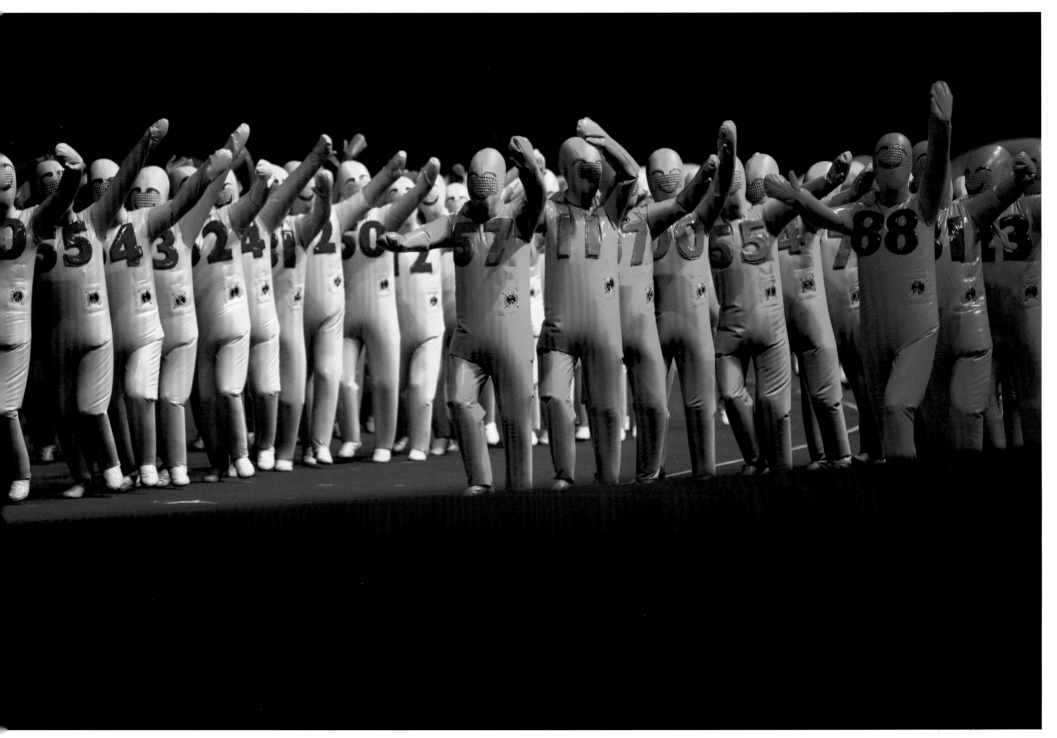

Paralympic Games Opening Ceremony, Beijing, China

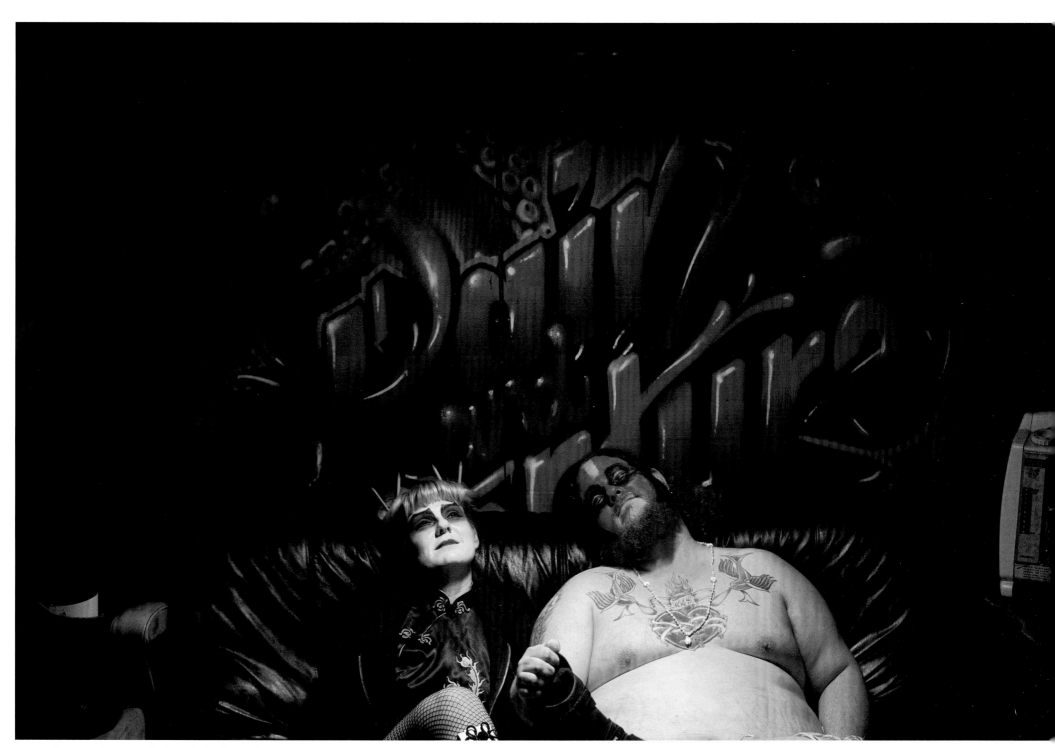

Extreme Pencil Fighting, Seattle, Washington, USA

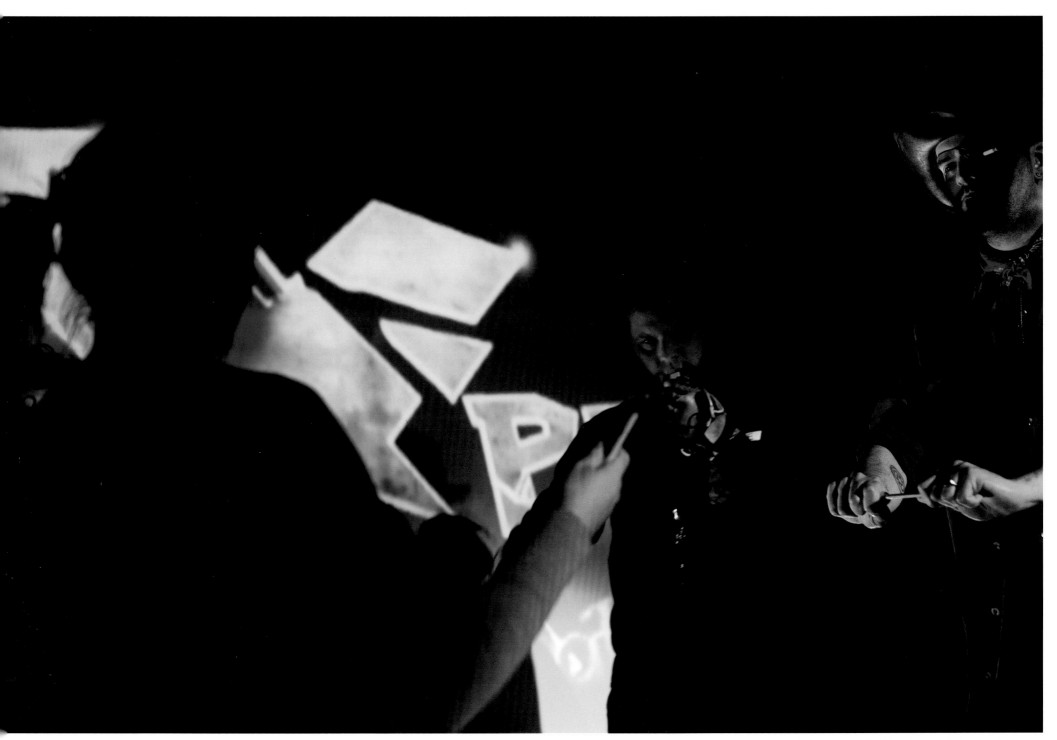

Extreme Pencil Fighting, Seattle, Washington, USA

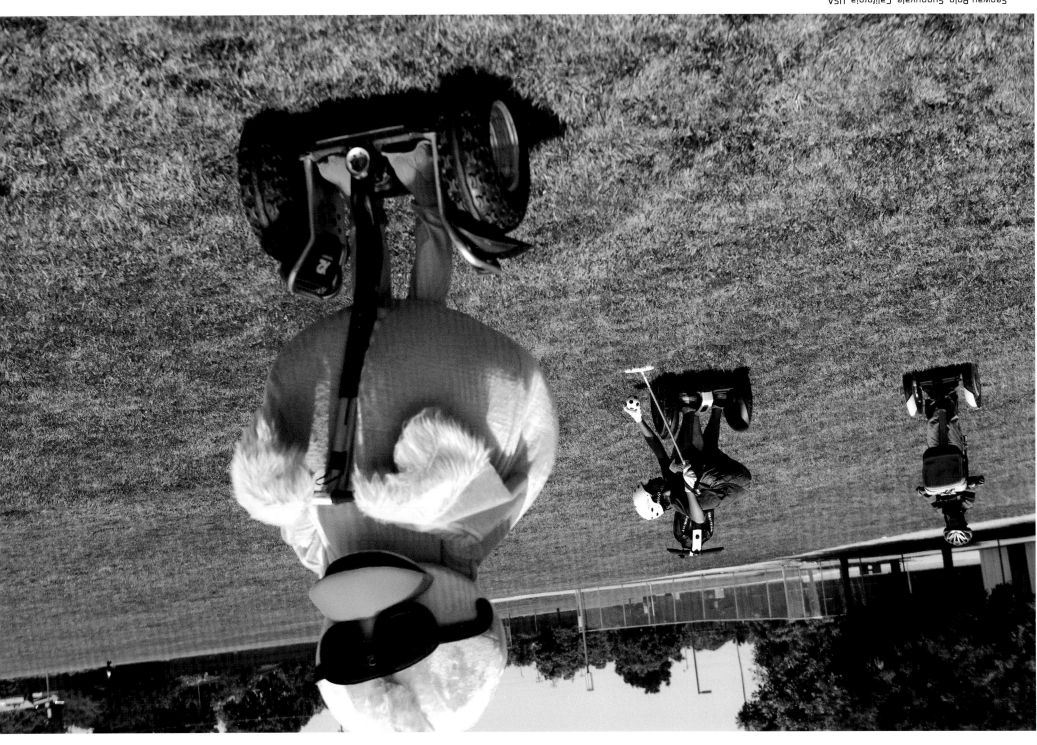

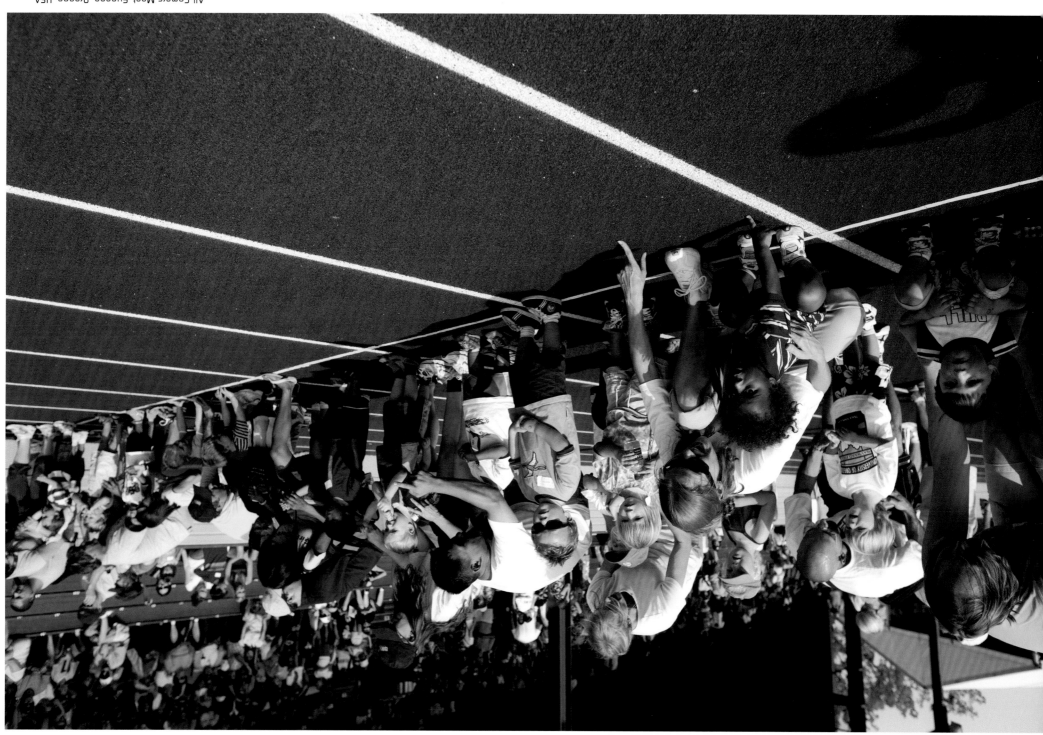

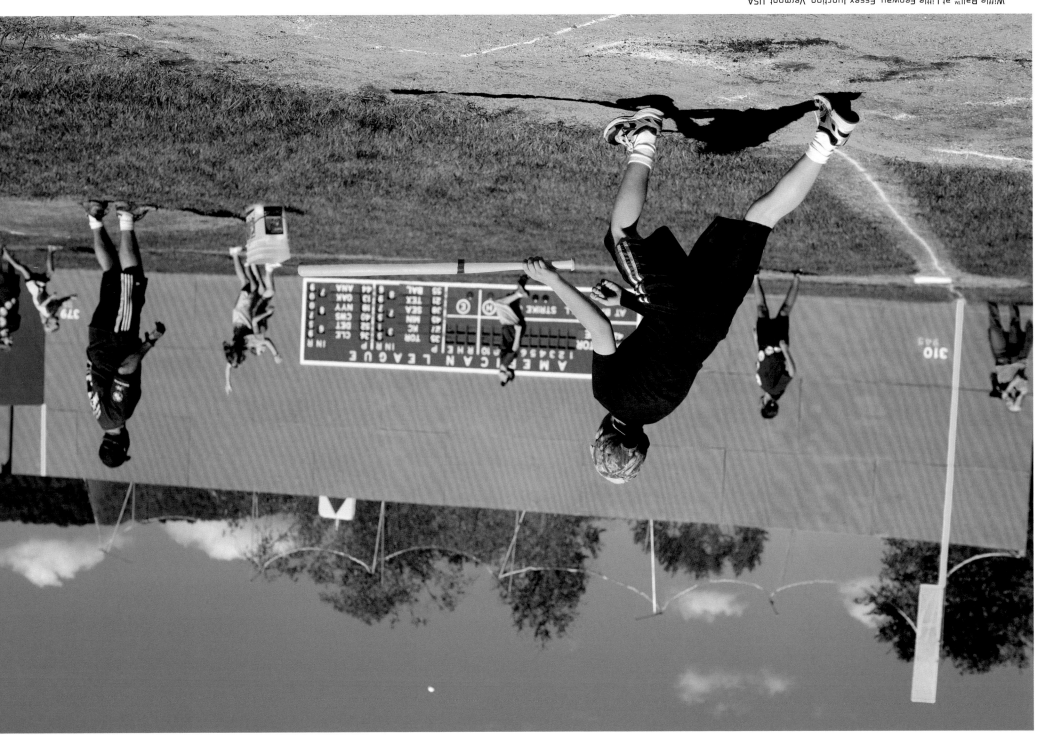

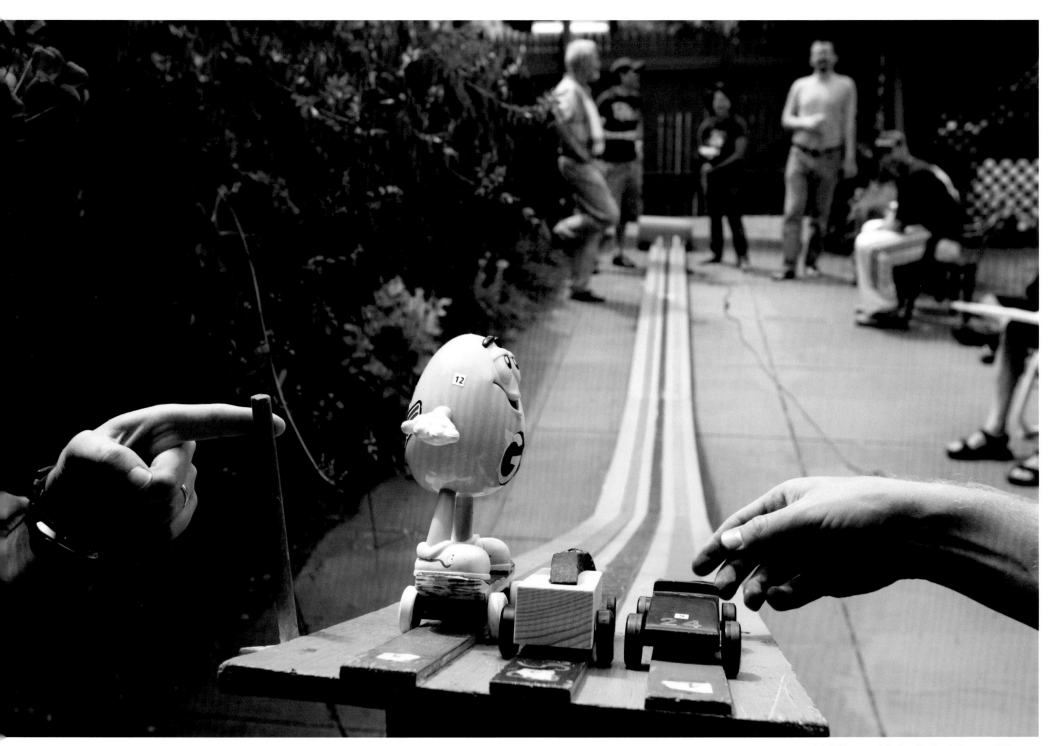

Adult Pinewood Derby, Portland, Oregon, USA

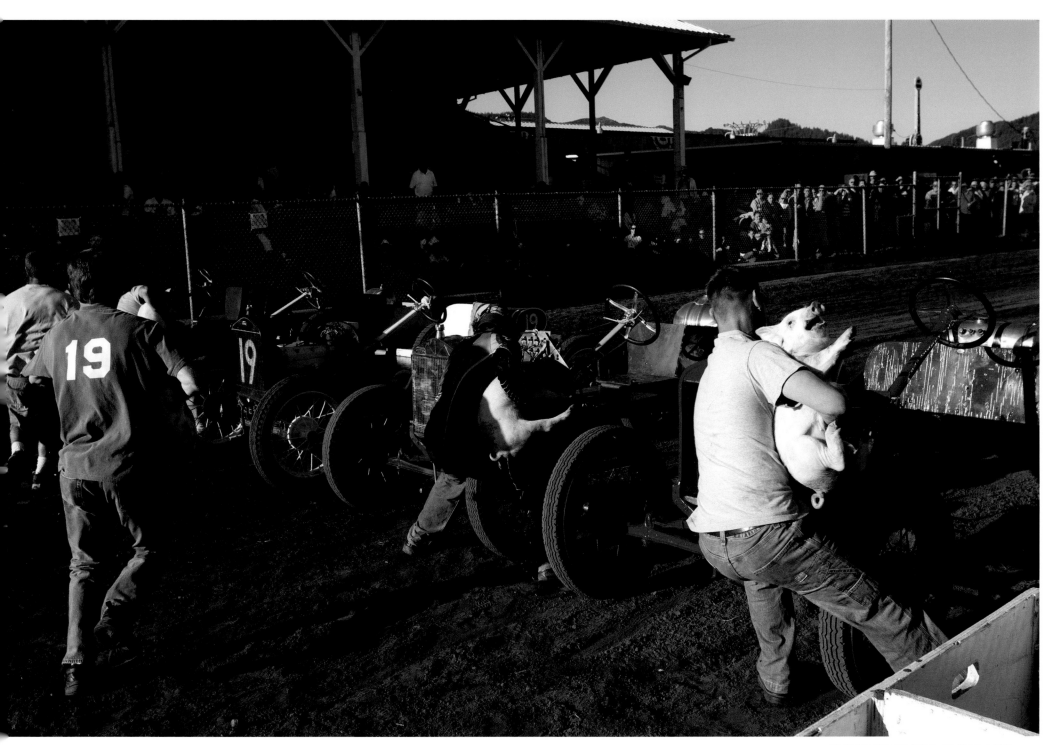

Pig-N-Ford Races, Tillamook, Oregon, USA

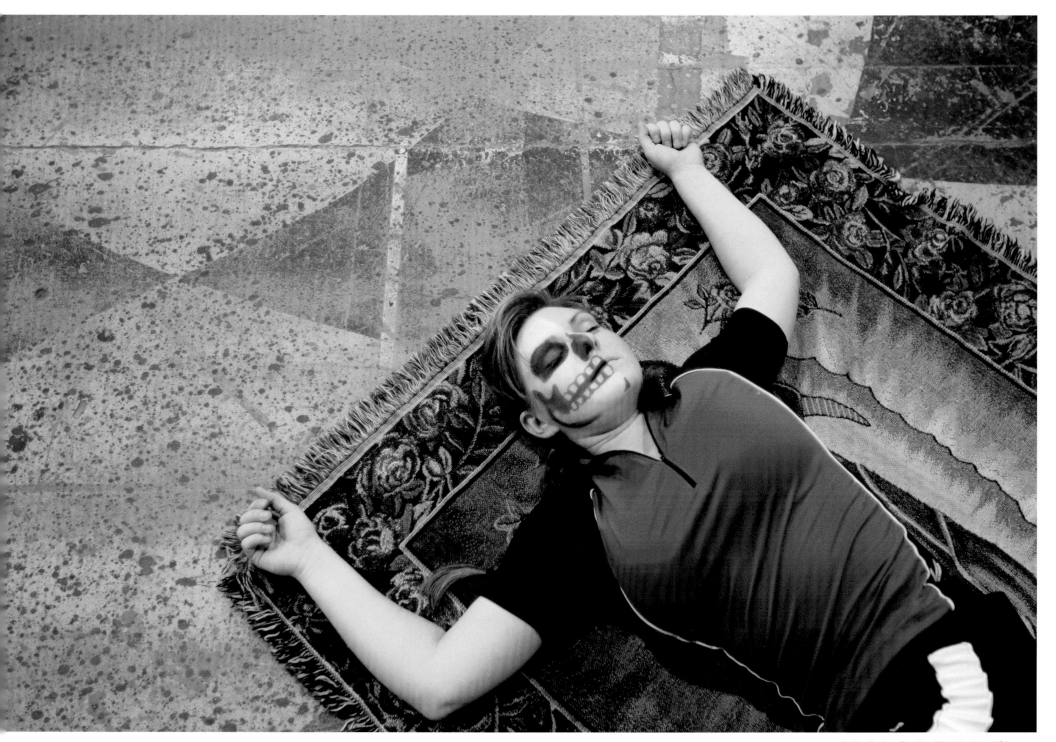

Roller Derby, Seattle, Washington, USA

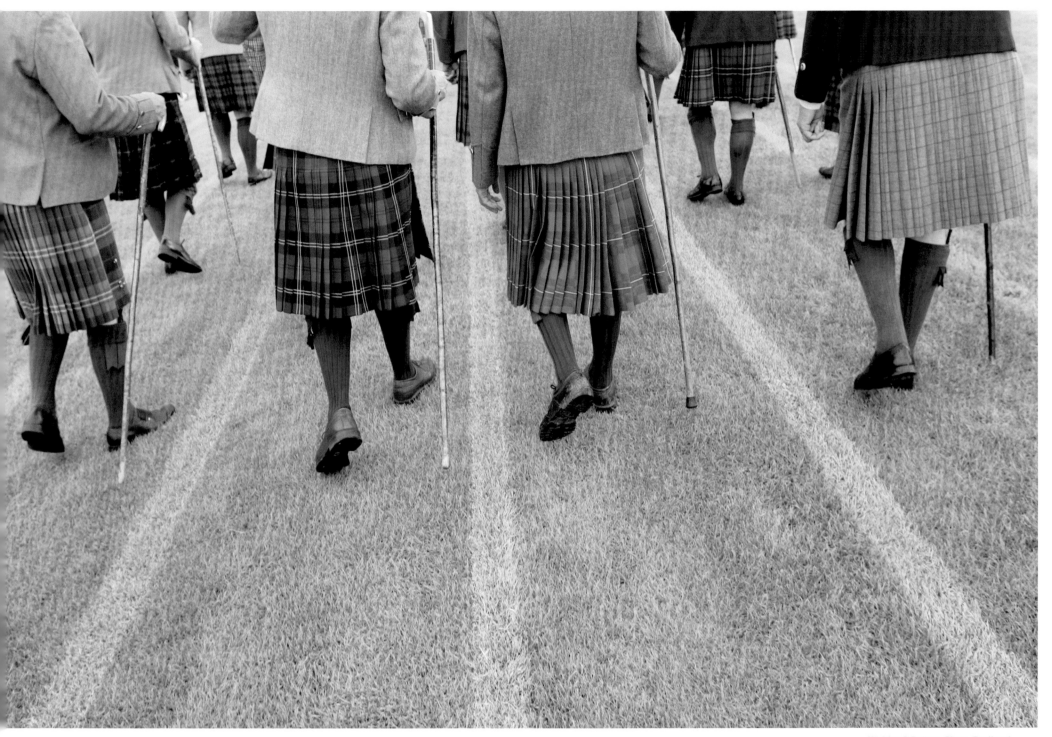

Highland Games, Oban, Scotland

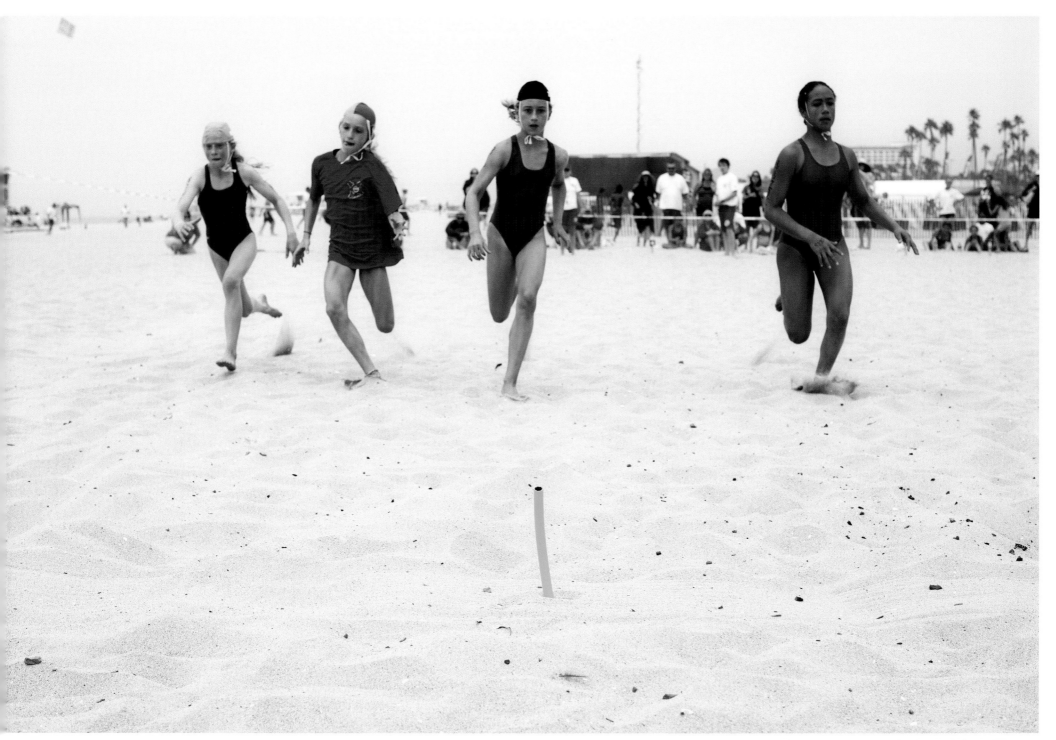

Beach Flag Race, Huntington Beach, California, USA

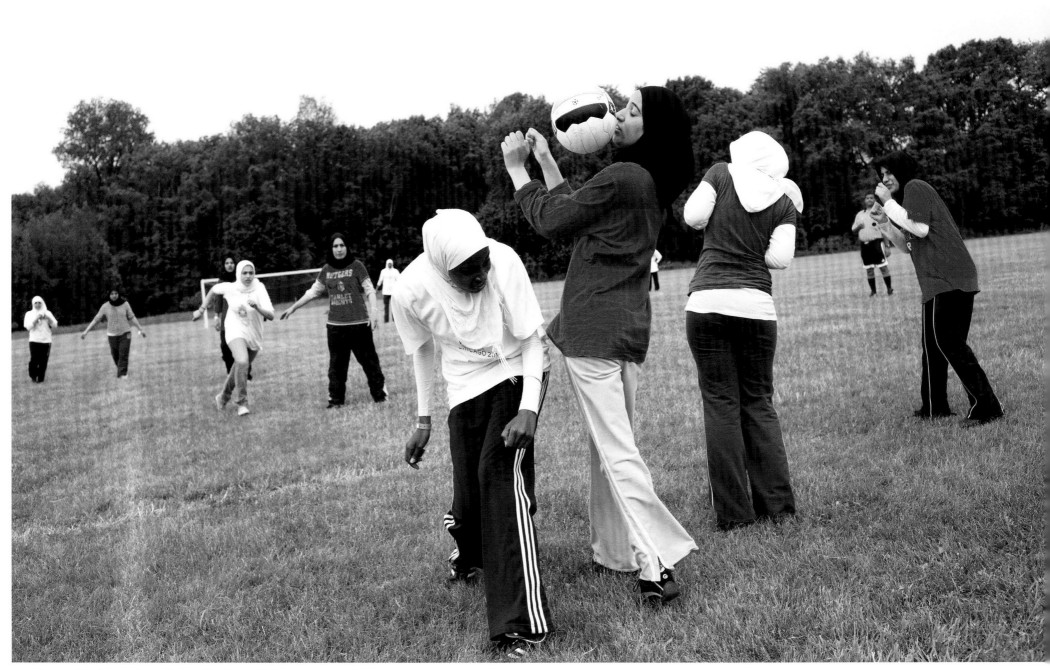

Soccer at the Islamic Games, Trenton, New Jersey, USA

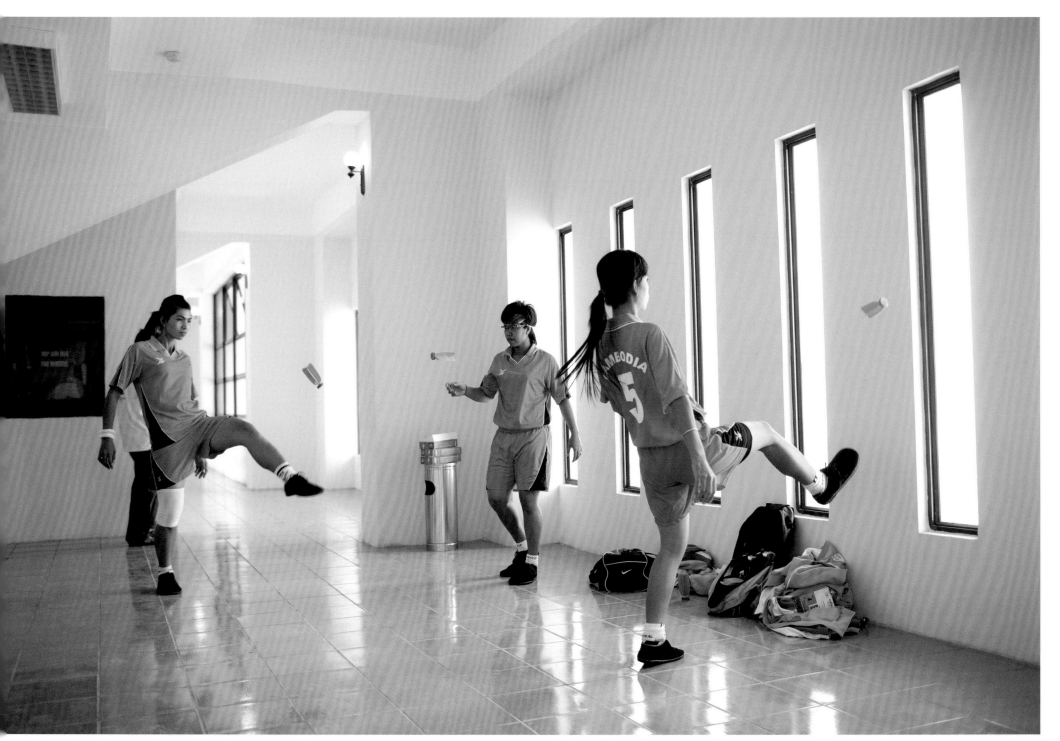

Shuttlecock, Hanoi, Vietnam

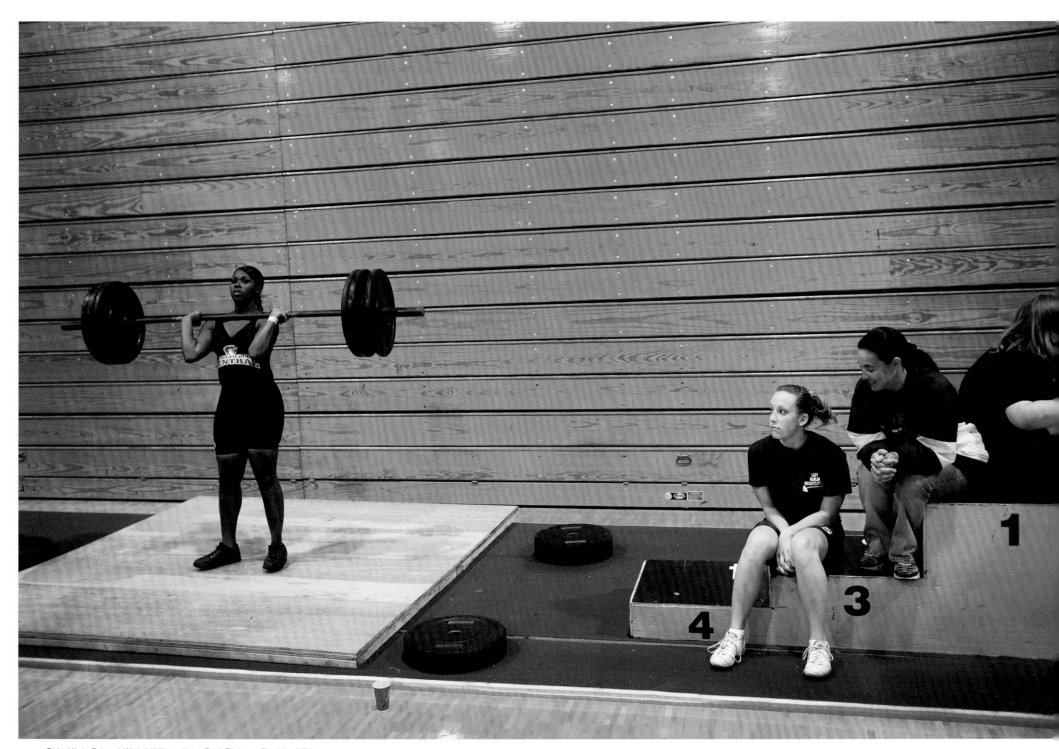

Girls High School Weightlifting, New Port Richey, Florida, USA

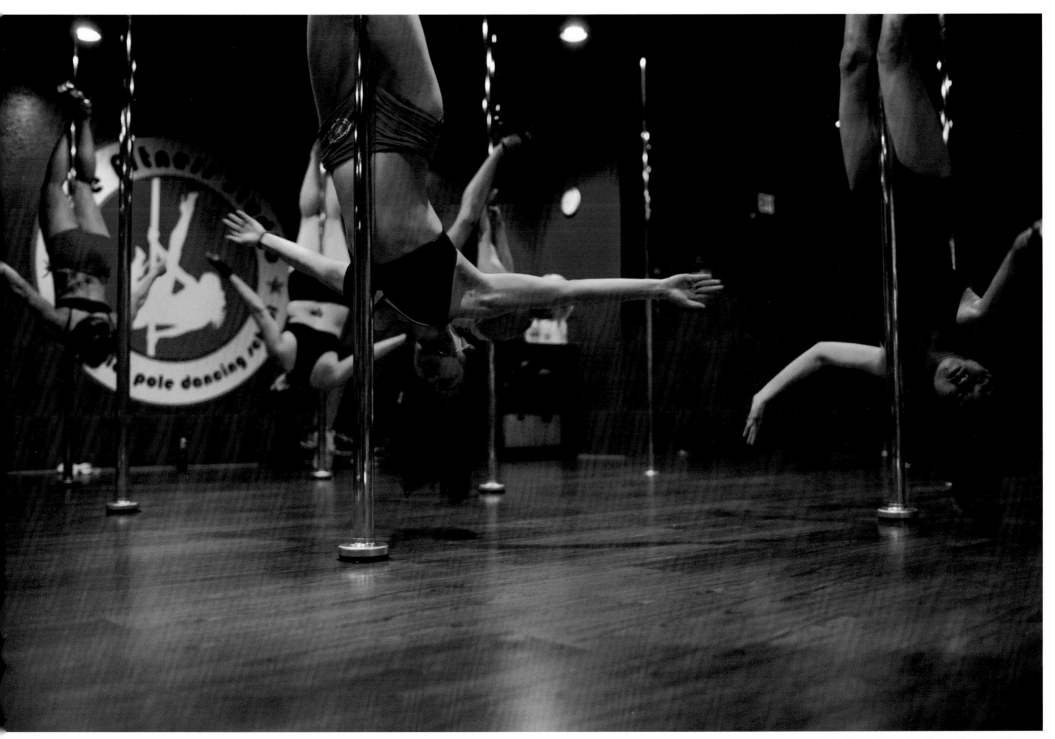

Pole Fitness Class, Las Vegas, Nevada, USA

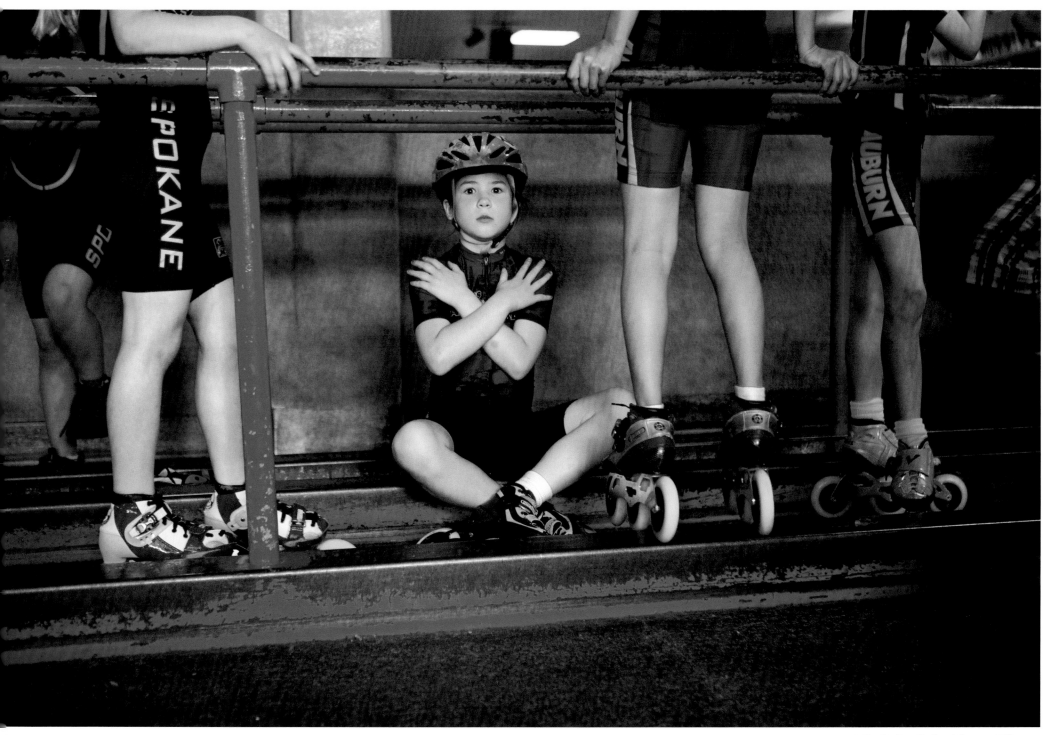

Roller Skating, Portland, Oregon, USA

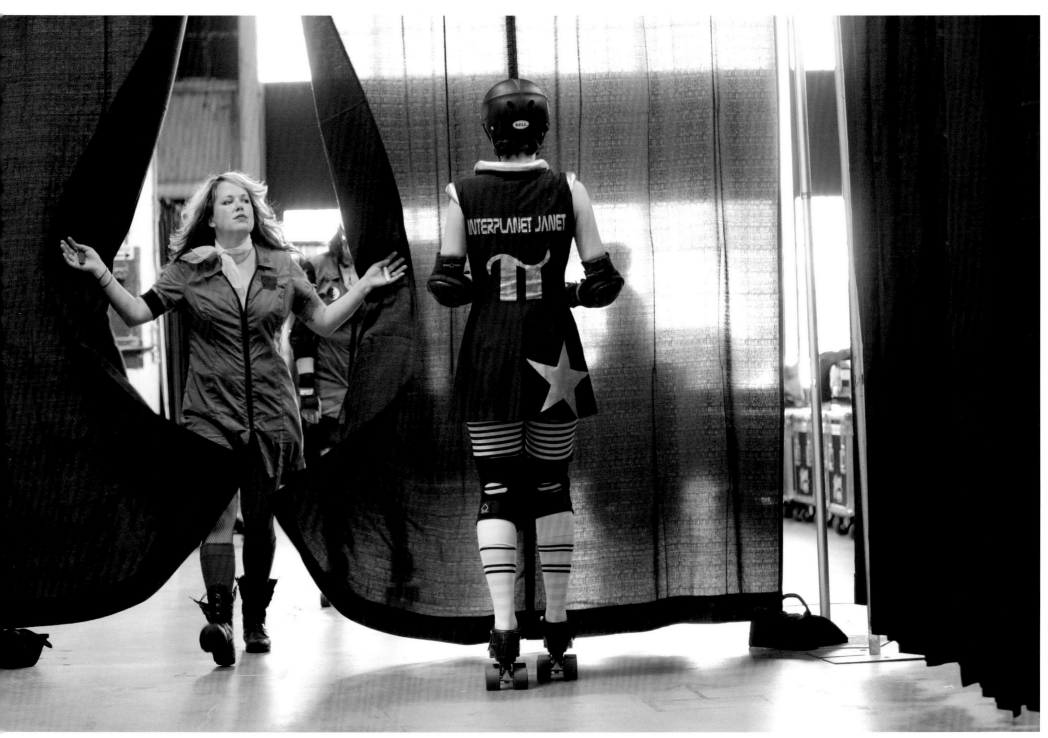

Roller Derby, Seattle, Washington, USA

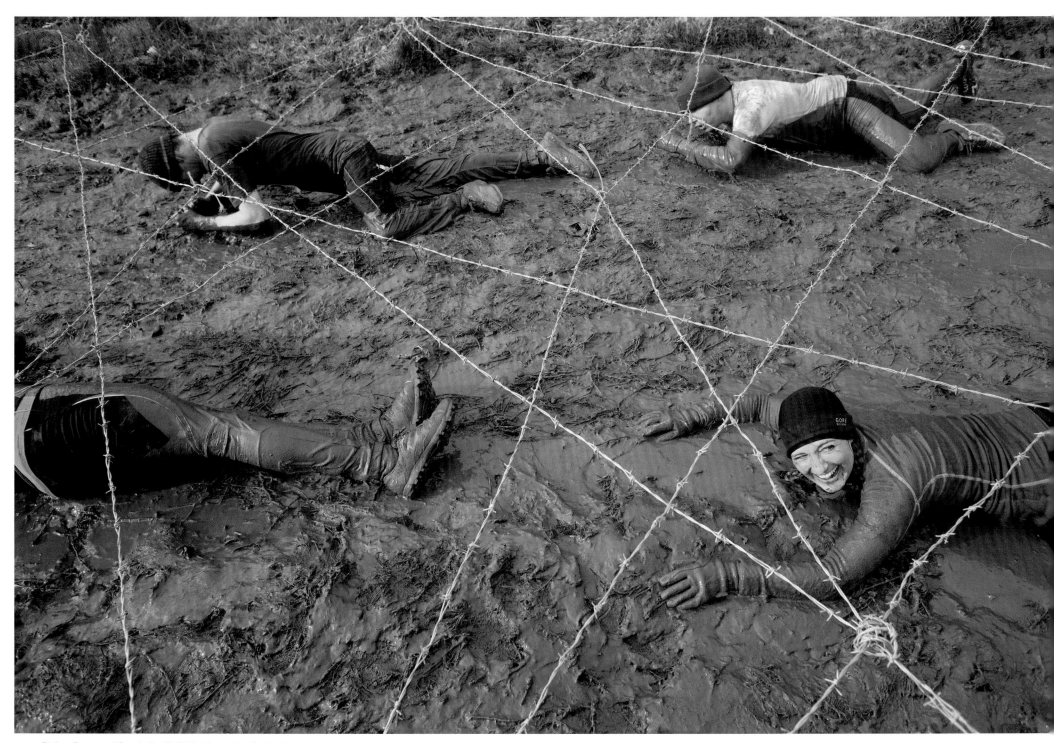

Stalag Escape at Tough Guy™, Wolverhampton, England

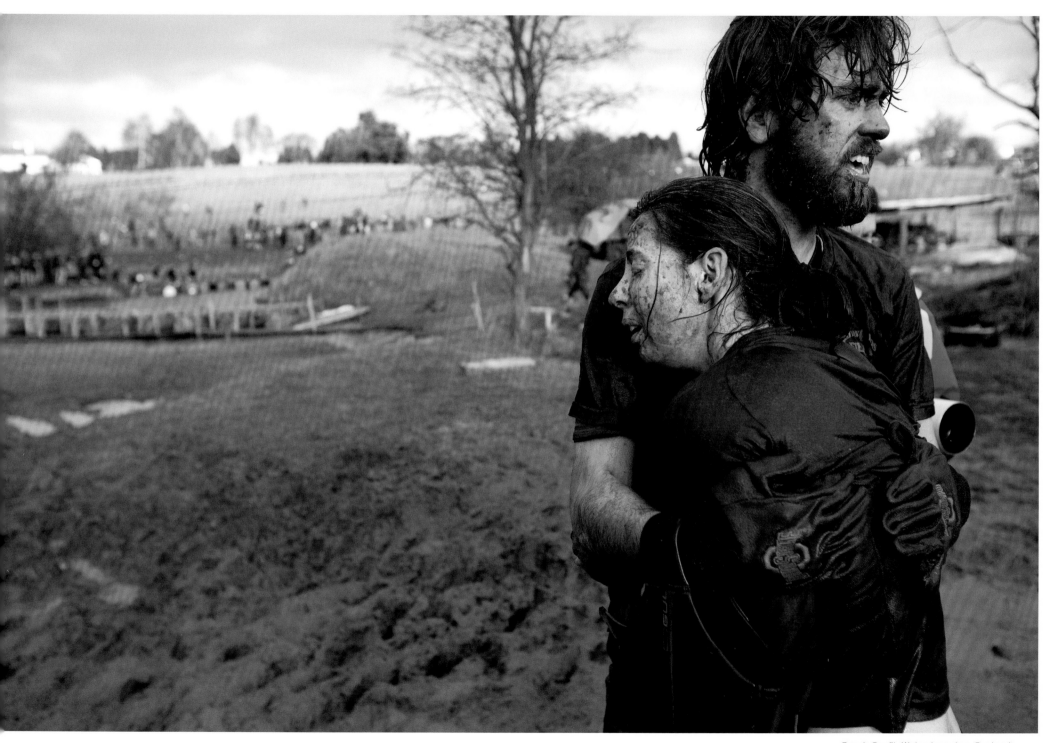

Tough Guy™, Wolverhampton, England

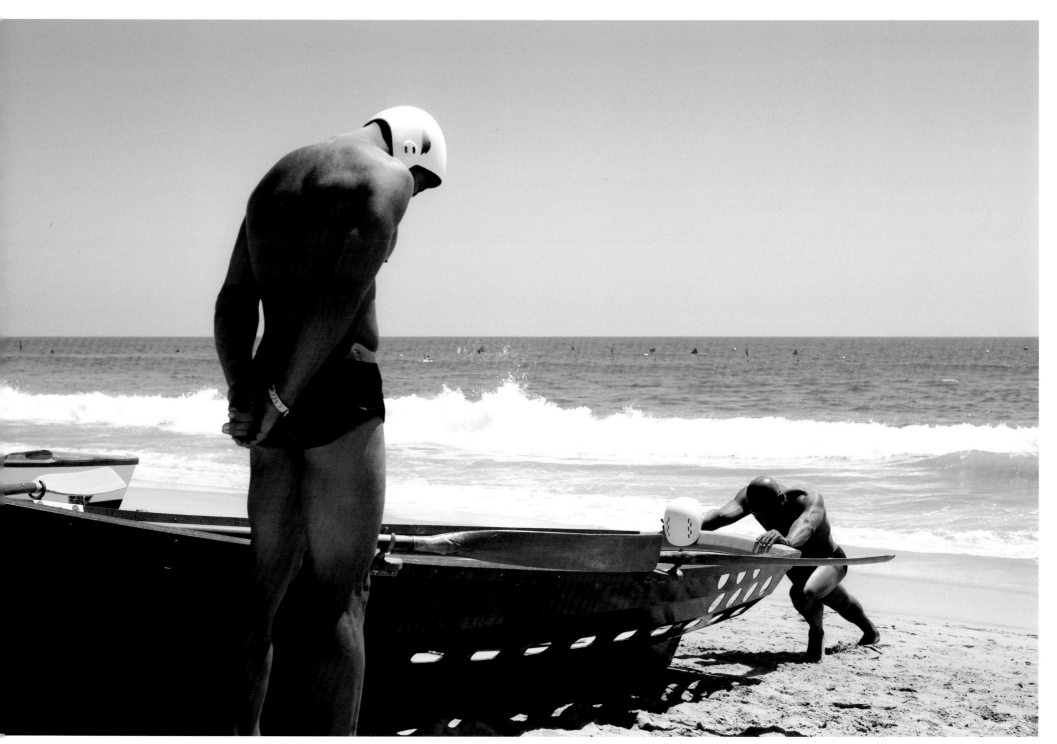

Surf Boat Race, Huntington Beach, California, USA

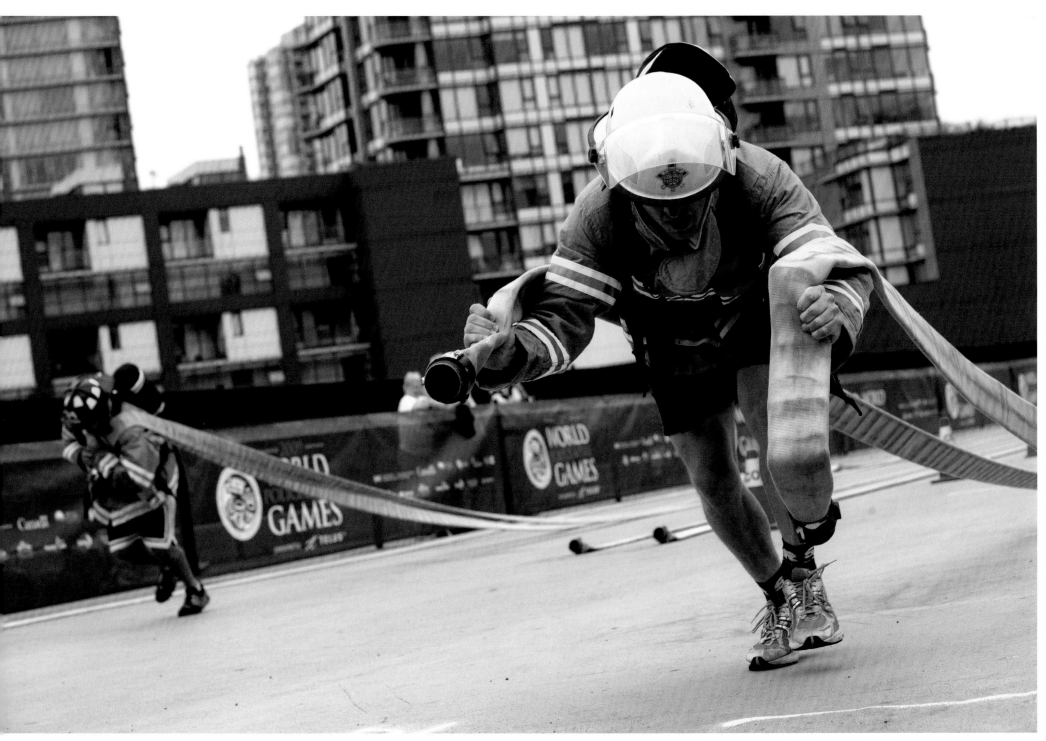

Ultimate Firefighter Competition, Vancouver, British Columbia, Canada

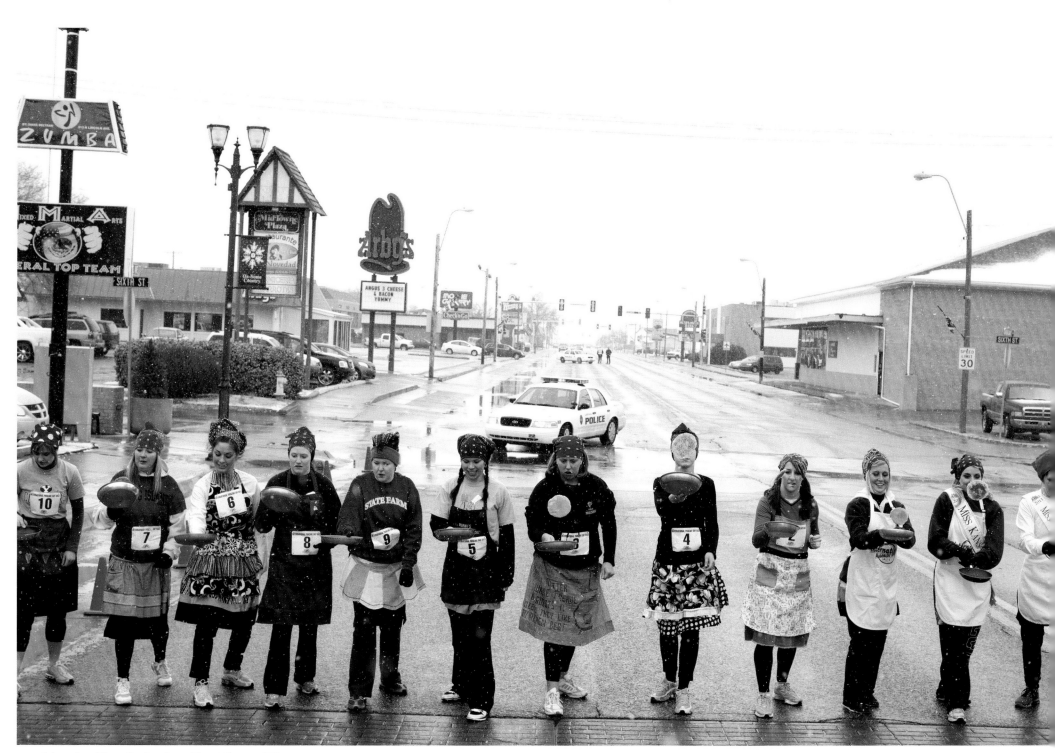

International Pancake Day Race, Liberal, Kansas, USA

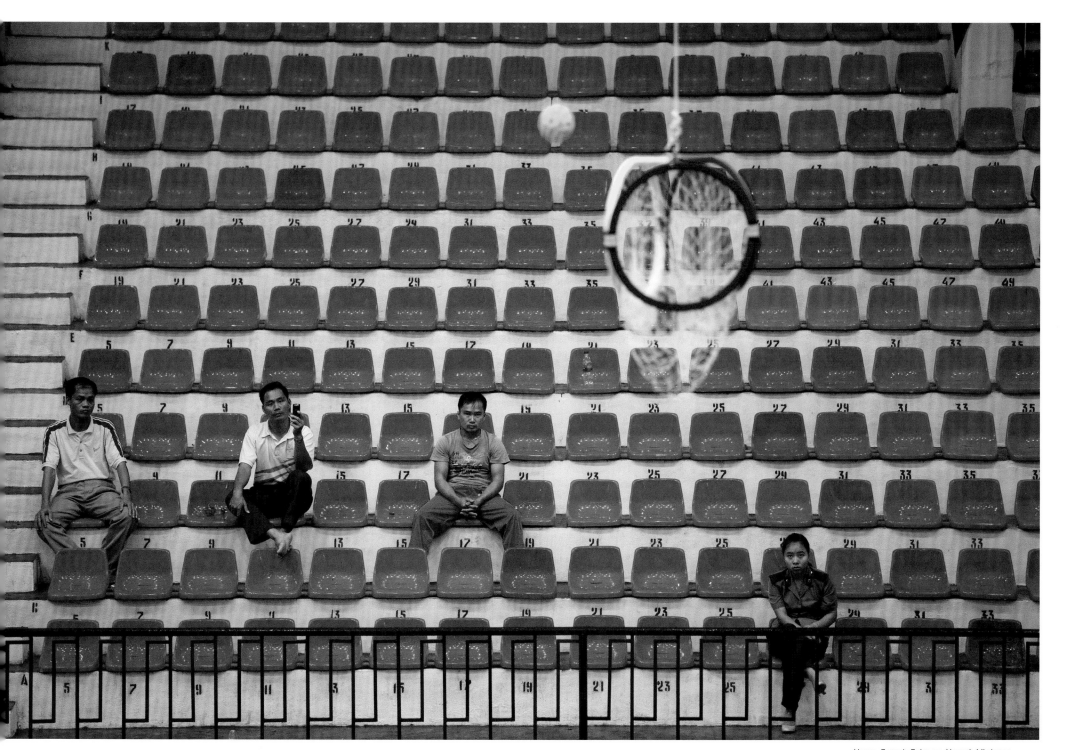

Hoop Sepak Takraw, Hanoi, Vietnam

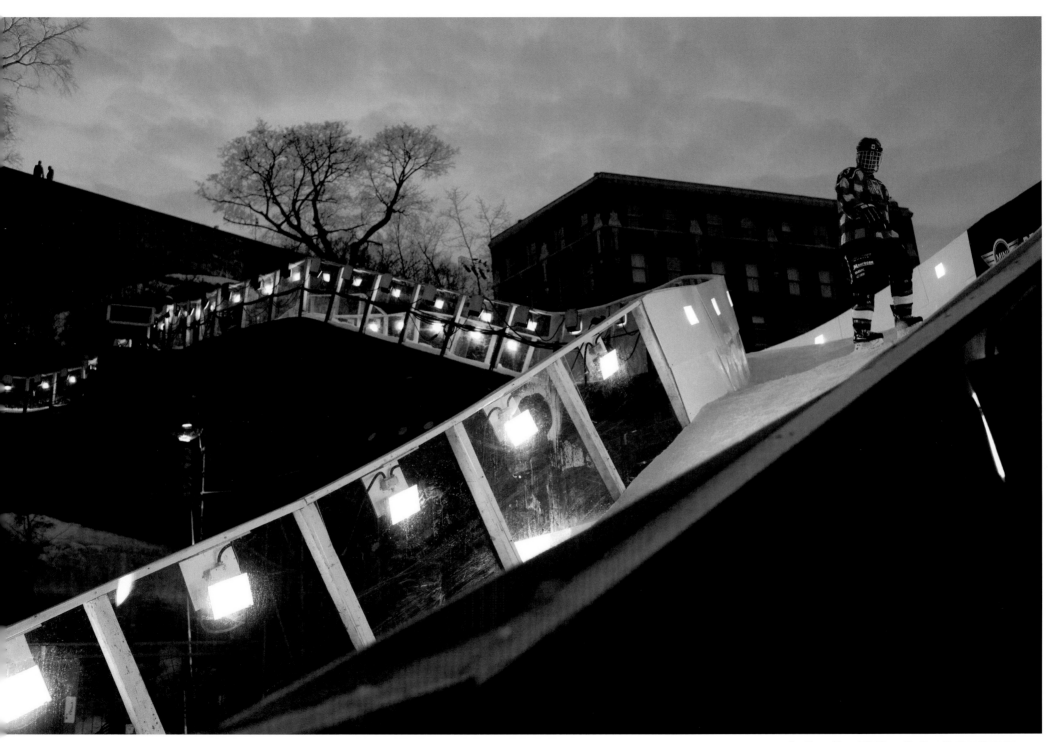

Ice Cross Downhill, Vieux Quebec, Quebec, Canada

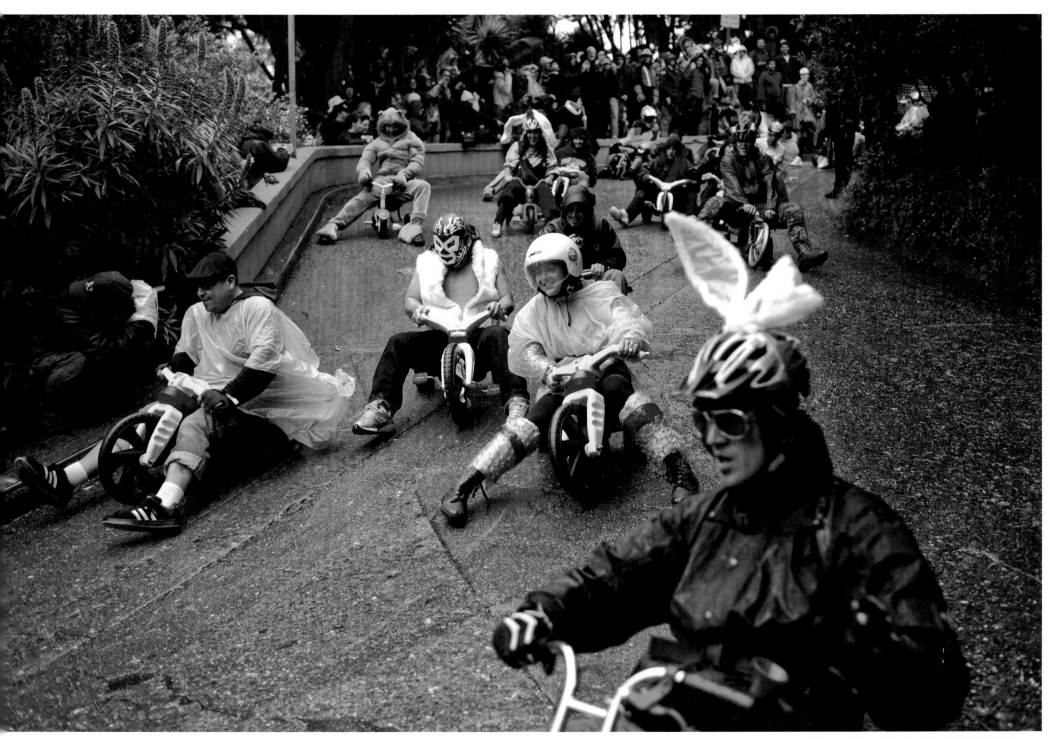

Big Wheel Race, San Francisco, California, USA

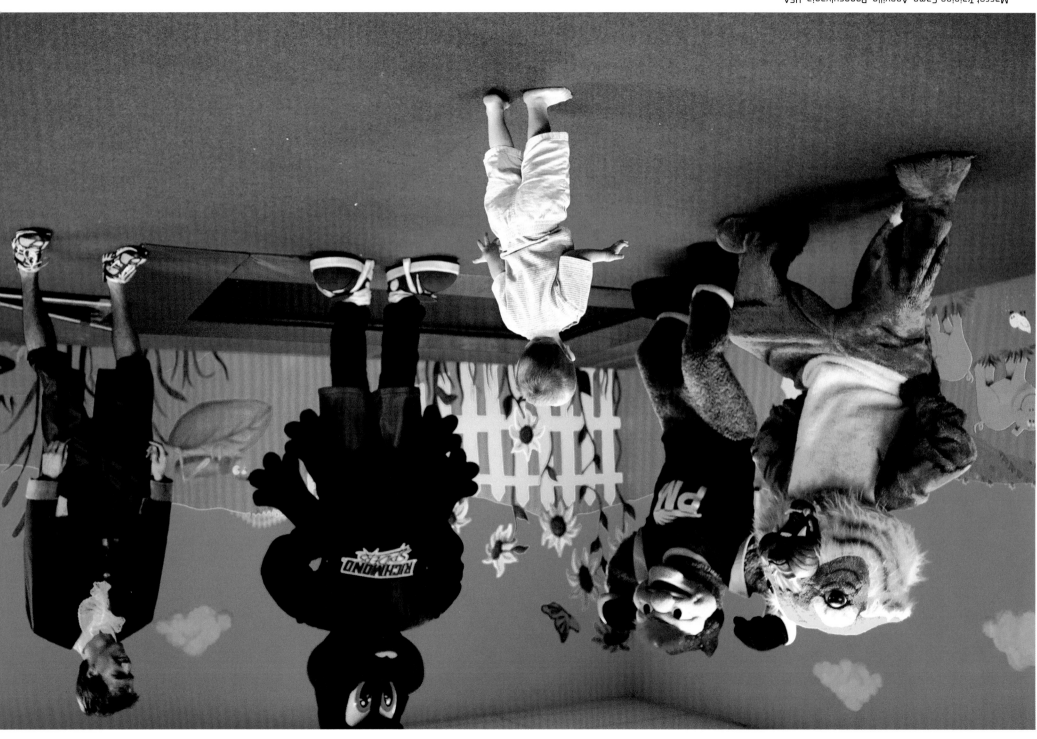

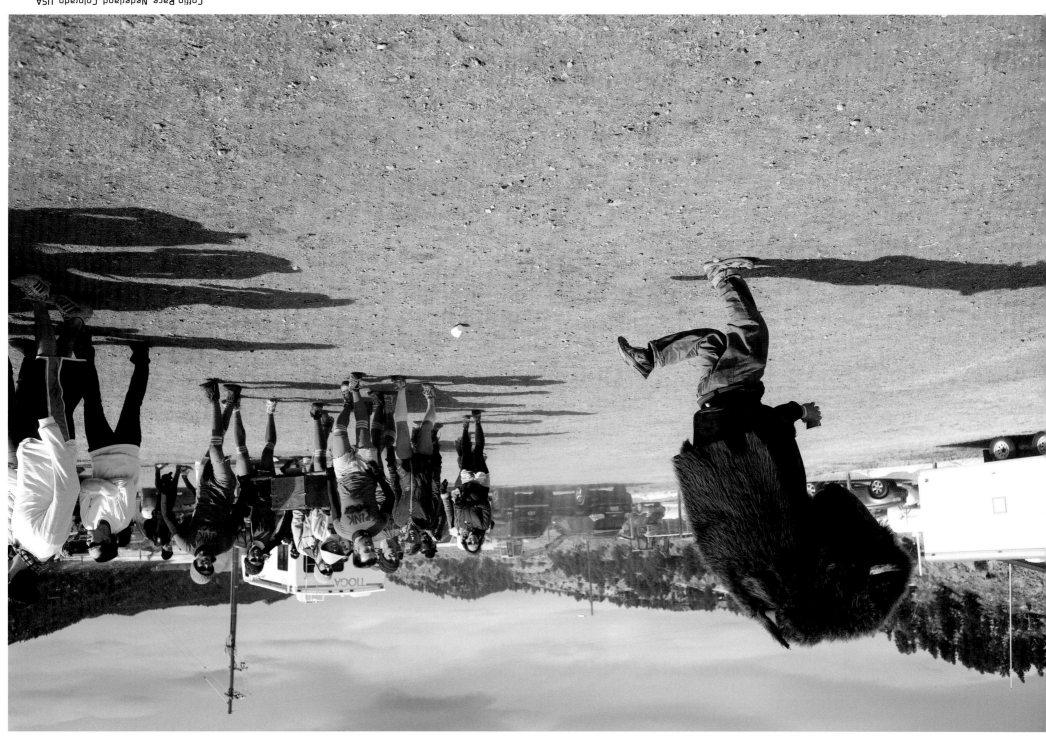

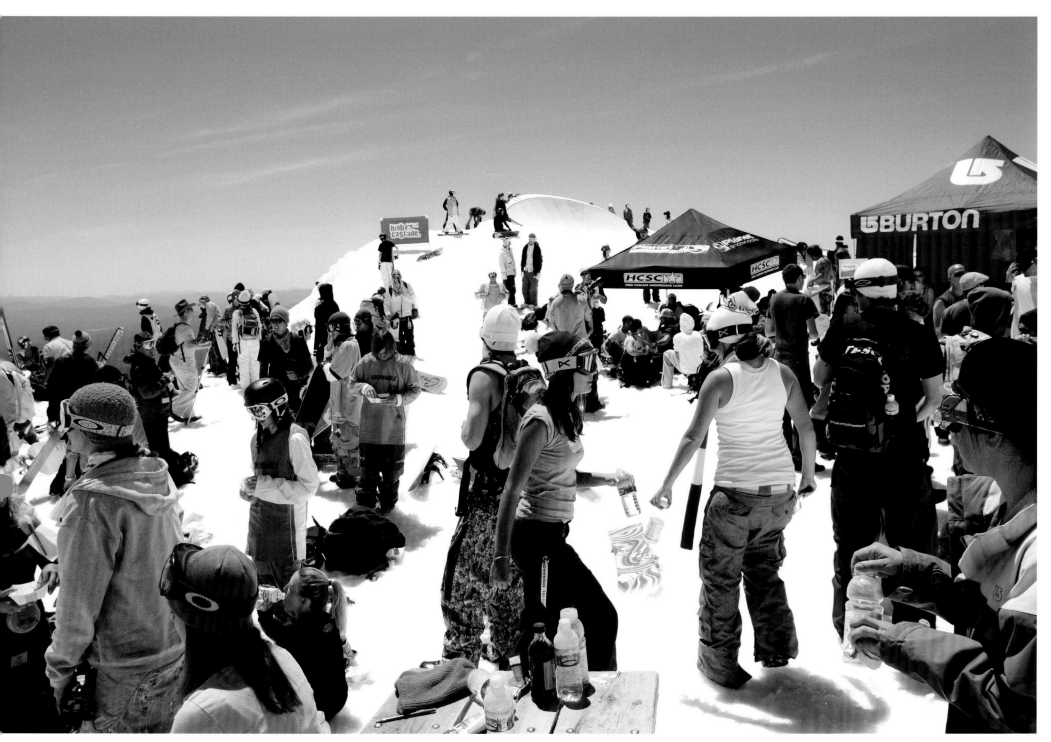

Summer Snowboard Jam, Mt. Hood, Oregon, USA

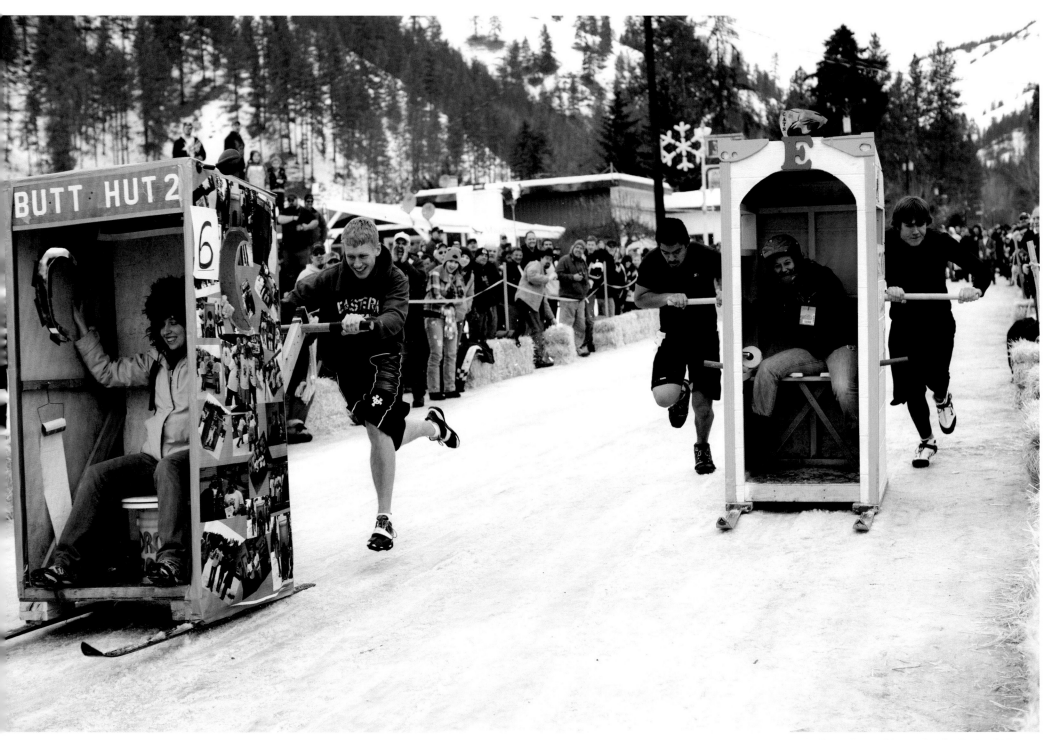

Outhouse Races, Conconully, Washington, USA

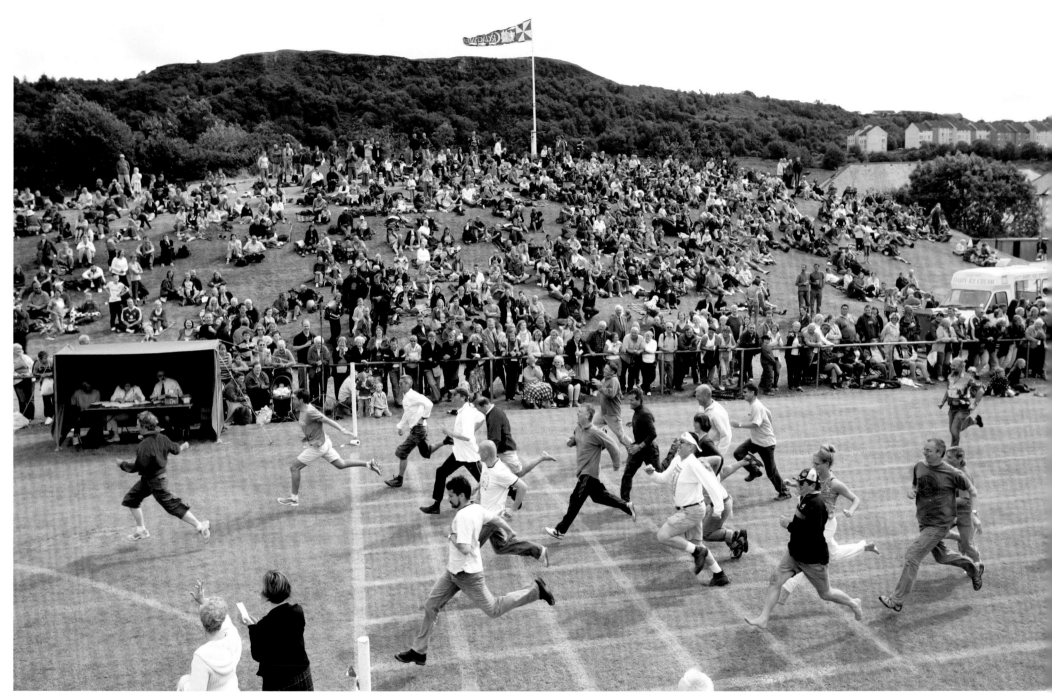

Highland Games, Oban, Scotland

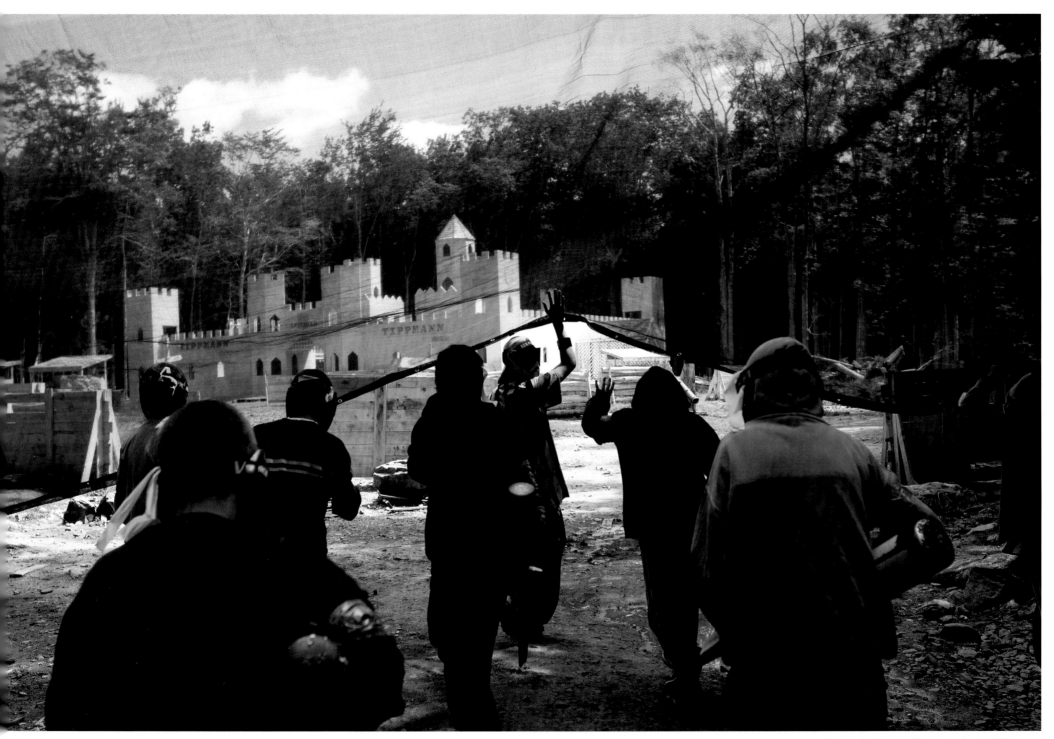

Paintball, Albrightsville, Pennsylvania, USA

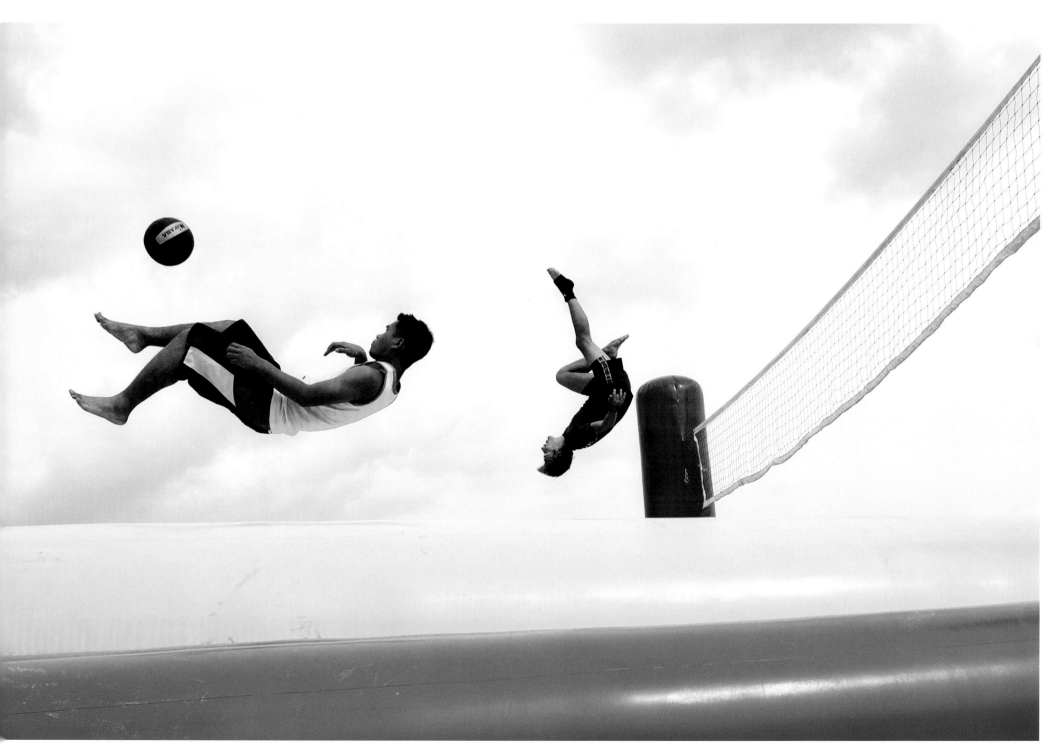

Bossaball®, Zoetermeer, the Netherlands

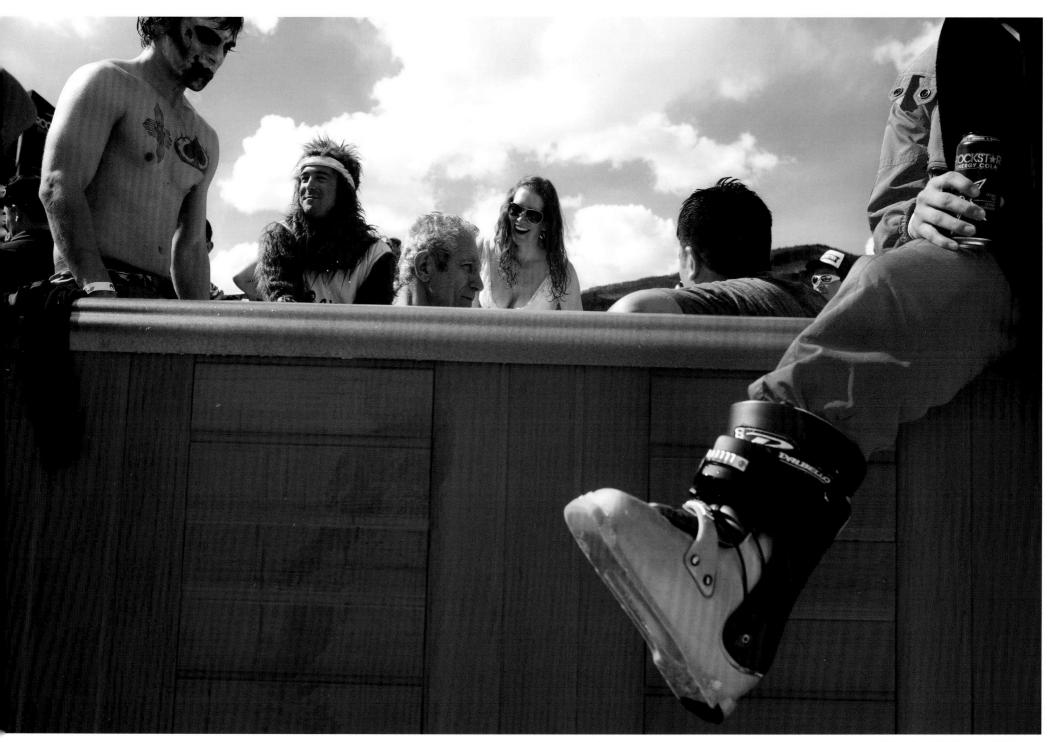

Pond Skimming, Vail, Colorado, USA

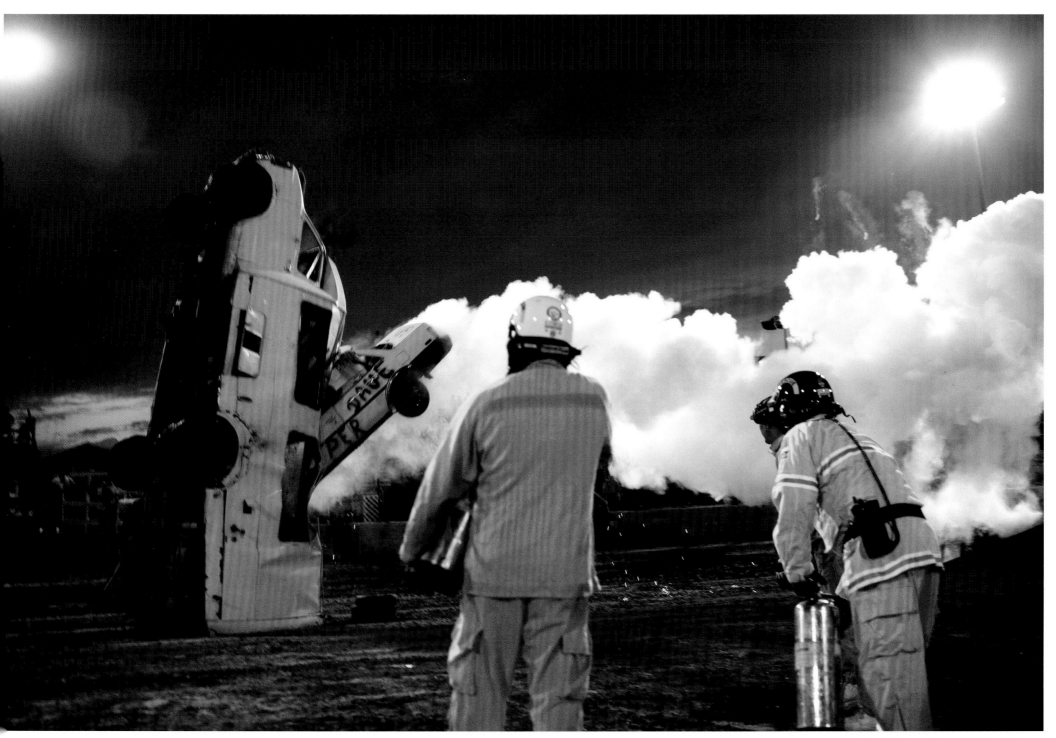

Crash-A-Rama, Tampa, Florida, USA

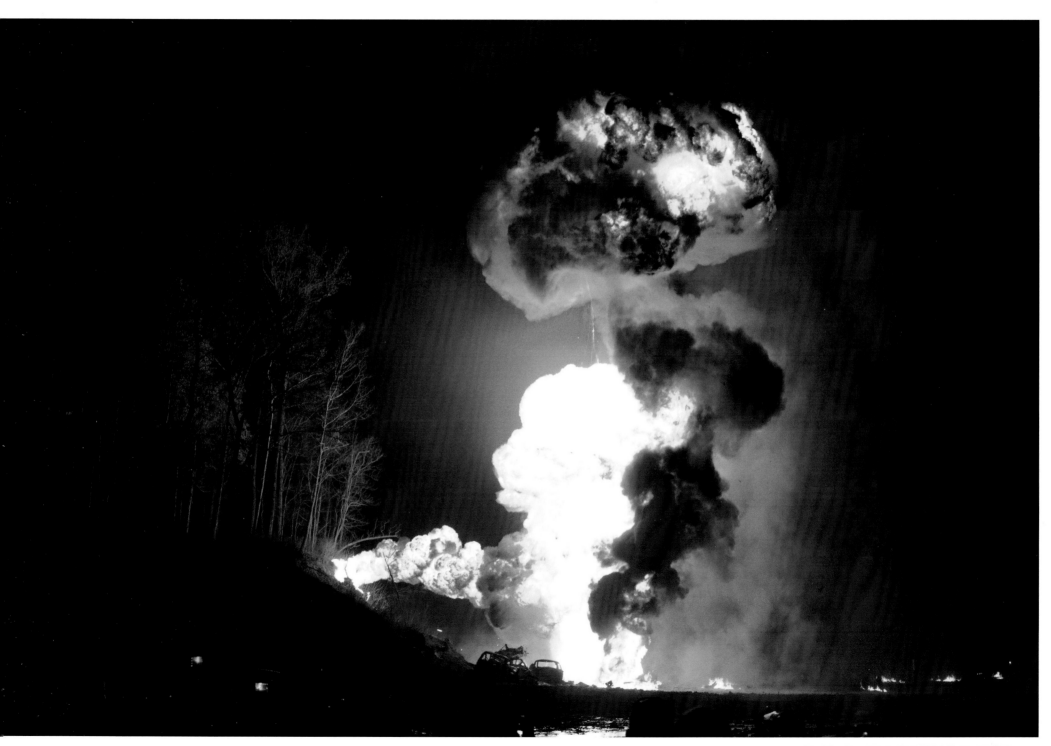

Machine Gun Shoot, West Point, Kentucky, USA

What's weird?

For too long, I feel, the narrow definition of sports has been limited to professional leagues and Olympic competitions, folks with monster builds and monster salaries. Sports are to be taken seriously, for the serious athlete. Does it really need to be that way?

Golf, while popular, is pretty elitist, and, I think, rather dull. But urban golf, played in the streets with tennis balls and recycled golf clubs, well that's just plain fun. And anyone can play. You don't have to be Tiger Woods.

What is weird?

I don't have an official answer, but I do know what is weird to me. Placing confused dogs on surfboards, playing touch football in lingerie, crawling under barbed wire—by choice. Those are weird to me. Wrestling pigs. Wrestling monsters. Weird. And weird. So are racing in Model T Fords with a pig under your arm, racing outhouses through town, racing downhill on Big Wheels. Hell, racing downhill on ice skates! All wonderfully weird.

What are sports?

Sports are what you want them to be. Inclusive, not exclusive. Sports allow people to express what matters to them, how they have fun, and where they are from. That's why dodgeball and kickball leagues have become the rage. Anyone, hell, *everyone* can play. Elite athleticism is not mandatory or expected.

So, what are weird sports?

That's up for discussion. There are no rules. Some of what I consider to be weird sports have been around long enough to become mainstream. But I remember a day when Evel Knievel *was* the X-Games, when snowboarding was a fad, when roller skating was something you did on a date.

Girls lifting weights is not weird. At the time I shot it, only the state of Florida had sanctioned girls' high school weightlifting championships. That I find unusual. Why isn't it in every state?

I hope that my use of the term weird is not taken out of context or considered derogatory. To me, it's about being unique and visionary. And that's why there's a photo of soccer from the Islamic Games in this book. Soccer isn't weird—except to Americans. A sports tournament devoted to Muslim athletes, to me, is cool and noteworthy.

I think that people strive to have their own identity—and to have fun doing it. Weird sports are communal, like-minded people having a blast together, reshaping something traditional while putting some of their own personality into it.

This book is not about creating a definition of what sports are or are not. It is about starting a discussion about what role sports play in people's lives. It is about simply celebrating fun.

Thanks to those that make sports weird.

Sol Neelman

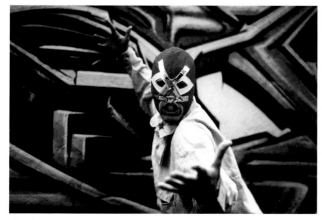

photo by m

Sol Neelman is a failed athlete turned sports photographer living in his home city of Portland, Oregon, USA.

A journalism graduate from the University of Oregon, he began his professional career in 1996 photographing the former Yugoslavia for an international humanitarian organization. In 1997, he joined a community paper in McMinnville, Oregon as a staff photographer. Three years there led to seven years of service at *The* (Portland) *Oregonian*. In 2007, he was part of a Pulitzer Prize-winning team of journalists recognized for reporting breaking news. He left his staff position that summer to pursue a lifelong photo project on sports culture around the world.

His images have appeared in a wide variety of publications, including *National Geographic, ESPN The Magazine, TIME, Rolling Stone, Newsweek,* and *The New York Times.* Nike, Umpqua Bank, eBay, and Ace Hardware are among his commercial clients.

Addicted to travel, he lives to discover interesting people with a crazy sense of humor. Some of the highlights: falling in love with Sarajevo, freezing in Poland, sweating in India, studying in Lyon, and shadowing Olympians in both Beijing and Vancouver. There was also that little-known gambling experience along the Trans-Siberian Railway.

Photos of the fun and weird sports he discovers are posted regularly on his blog at solneelman.com.

Acknowledgements

This book would not have been possible if not for the unconditional love and support of my mom, Rob, and the entire Kangas family. The same is true for an amazing collection of photographers I am fortunate to call dear friends. Thank you. And for everyone who offered me a couch—either for late-night crashing or therapeutic advice—a big shout-out goes to you, too.

I'd like to extend special thanks to (in cryptic, alphabetical order) the inspirational community of aphotoaday.org, Ahmet, Berner, Alexa und meinen neuen Freunden vom Kehrer Verlag, Andy, A to the Z, Ashley and Detrick, Pants and Noles, Bart & Amy & Luke & Drew, Croz, R2R, Thunderbird & Kristi, the Mapps, Chip & Elaine, the Pietsch family, Chris, Craig, Dale, Rooter the Shooter aka Hebrew Hammer 0.5, Hammer & Anvil, David, Deb and Mike, Doan, Emily, Erika, Eugene, Aunt Fran, CFKSEFE, Sehorn, Gina, Ian & Steph, J$, Jason, Jerome & Shirley, The General, Bossman, Josh x2, JUDY!, Just In Kase, Karen, Karl, Ken, German, KLS & Paula, Laara*, Roy, Jenni, Glen, Resa, The Boss, Maren, Martin, Eich, MMM, Slaby, Joe, lyttle m, friends of the Goddess of Victory, Patrick and the Pendergasts, Fuckin' Paulie & Schelman, Peter and all those silly Getzlaffs, anyone with the first name Rob and the last name either Finch, Gauthier, Kerr, Mattson or Romig, the Wentes, Sadie Q, Strazz, Seth, Bittle, Yao, Bags, TJ, Tara, TBrown, the LaBarges, Boyd, Trenthead, T$, Umpqua Bank aka The World's Greatest Bank, Val, and Yooners.

Tamika, you made the book. How crazy is that?

In our early 20s, my best friend Tara and I would regularly visit a strip mall cafe in suburban Hillsboro, Oregon, and dissect and discuss photo books over coffee. We had lots of questions. What makes a good photo? What makes for a bad photo? Does a photo mean more or less because it's taken in Ethiopia or Illinois? Why do photographers make certain photos? Do they really change anything? Does it matter if they don't?

I fell in love with photography through photo books. For Christmas 1988, my mom gave me *The Best of Photojournalism/13* and wrote: "A glimpse of some good stuff…!" It quickly became the standard which I strove to reach. My goal was to win something in that annual yearbook of photography's best images, something that other people would dissect and discuss over coffee. Ironically, the first time I won an award in *Pictures of the Year* was the first year they stopped printing that book. In the mail I got a certificate and an unsatisfying CD-ROM of the winning images. I knew contests are arbitrary and subjective, but I wanted to be in that book, to be part of the discussion.

Fast forward to 2005, when a colleague* asked me a question that rocked my world: "What do you love doing?" I felt stupid because I didn't have an answer.

Having worked for newspapers for several years at that point, I had never asked myself that question. Shooting a big game or news event had become my focus. Making chicken salad photos from chicken shit photo assignments, that's what I was good at. I was a newspaper shooter. Yeah, that was cool. But what did I love doing?

My answer: Photography. Sports. Travel. Weird shit.

And in that instant, I realized my mission: to photograph weird sports around the world.

When I quit newspapers in 2007, I set out to track down fun(ny) sports photo ops, trying to make photos that made me smile and laugh and feel and think. Folks would ask, "Who you shooting this for?" I'd answer, "Myself. I'm doing a book." Never did I think it'd happen, just that it was a good, healthy goal.

Fast forward to now. I have published a photo book, a record of things I've witnessed on this planet. It's not perfect, but neither am I.

I just hope that if a younger Tara and Sol were sipping coffee at a strip mall cafe flipping through these pages, they'd smile. And laugh. And feel. And think.

In memory of

Alexandra, Christi, George, Jerry and R. Thomas

© 2011 Kehrer Verlag Heidelberg Berlin, Sol Neelman and authors

Editor: Mike Davis

Foreword: Brandy Rettig

Proofreading: Wendy Brouwer

Image processing: Kehrer Design (Jürgen Hofmann)

Production and design: Kehrer Design (Tom Streicher, Katha Stumpf)

Bibliographic information published by the Deutsche Nationalbibliothek. The Deutsche Nationalbibliothek lists this publication in the Deutsche Nationalbibliografie; detailed bibliographic data is available on the Internet at http://dnb.d-nb.de.

ISBN 978-3-86828-219-1

Kehrer Heidelberg Berlin
www.kehrerverlag.com